IMAGES
of America

# CAROWINDS

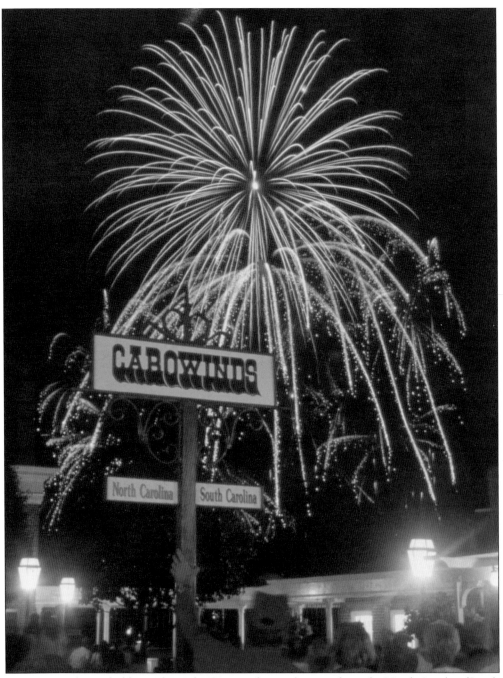

Summertime fireworks bloom above the Carowinds sign that stands on the North Carolina/South Carolina state line near the park's main entrance. (Courtesy of Carowinds.)

ON THE COVER: Thunder Road, which opened in 1976, was Carowinds' largest ride to date and the only wooden roller coaster in the country that actually took passengers through two different states (North and South Carolina) during the ride. It remains one of the park's most popular attractions. (Author's collection.)

IMAGES
*of America*

# CAROWINDS

Scott Rutherford

ARCADIA
PUBLISHING

Copyright © 2013 by Scott Rutherford
ISBN 978-1-4671-2003-6

Published by Arcadia Publishing
Charleston, South Carolina

Printed in the United States of America

Library of Congress Control Number: 2013930896

For all general information, please contact Arcadia Publishing:
Telephone 843-853-2070
Fax 843-853-0044
E-mail sales@arcadiapublishing.com
For customer service and orders:
Toll-Free 1-888-313-2665

Visit us on the Internet at www.arcadiapublishing.com

*This book is dedicated to my mom and dad, who accompanied me on my very first real wooden roller coaster—the Shooting Star at Ohio's Coney Island. That experience ignited a heartfelt passion for coasters and amusement parks that refuses to fade.*

# CONTENTS

# FOREWORD

In spring of 1973, I listened to the radio as E. Pat Hall welcomed the opening day crowd to his brand new theme park called Carowinds. The excitement in his voice immediately captured my interest. When I returned home from college, I thought I would look into getting a summer job there. Little did I know that summer job would become much more.

The day I applied for my first job I made a left turn onto Avenue of the Carolinas and found myself in the middle of a new and very large parking lot. A large black car came speeding around the corner. The driver pulled up, rolled down the window with much authority and no hesitation, and he asked, "What are you doing here, son?"

It took a couple of seconds for me to gather myself, and I more or less ended up telling him an abbreviated life story. He paused and said, "Follow me." We drove to a large brick building. Inside he said, "This young man is looking for a job." Then just like that he disappeared through a door.

A lady explained what jobs were available. Being a poor college kid, I said security since it paid $2.25 per hour, much better than the $1.65 for other jobs. She promptly took me to the office of Jennings Hayward, head of Carowinds Security. He and I hit it off, and I soon had a job. After an orientation and a trip to wardrobe, I thanked the ladies in the front office and told them how relieved and happy I was to get a job at Carowinds. One of them replied, "You shouldn't be surprised. If you weren't Carowinds material, E. Pat Hall wouldn't have brought you in here." My jaw dropped. All these years later, I still think about that day and wonder how different my life would be if I had taken the time to read the road signs.

I spent three seasons working in security while I was in college and grad school. Every day was just plain fun. I got to meet and help people, watch them laugh and be kids again. I saw children shout with glee when they spotted the animals in the petting zoo or climbed onto the EPH Railroad to take a train ride around the park. I felt lucky to be a part of it all.

In the summer of 1973 I met Irene, a beautiful brunette. I figured she was "way above my head," and it took two seasons for me to get the courage to ask her out. To this day, my lovely wife still contends that my initial assessment was correct; she claims she felt sorry for me and decided to go out with me anyway. Thanks to Carowinds, I found the love of my life.

At the end of the 1975 season, I took a job as an accountant for a local hospital. I thought it was time to put my new degree to work. While I enjoyed my job, I still missed the magic of Carowinds. So when the phone rang in October 1976, I jumped at the chance to become the assistant security manager for Carowinds. From then until now, I have never looked back. My job responsibilities have varied and grown through the years, as have the rewards. I have seen the great coasters from Thunder Road to the Intimidator go up piece by piece to the delight of our loyal guests and fans. I have watched great artists deliver amazing performances to packed houses in our Paladium. I have marveled at the night sky filled with fireworks, shared the joy of a mom or dad getting a big hug as their little one emerges from one of our kiddie rides for the first time, and never get tired of seeing Old Glory raised to the top of the Sky Tower for the first time each season. All have created great memories and have enriched my life.

My experiences and memories are multiplied exponentially by those who have worked, played, and basked in the aura and magic of this special place we call Carowinds. May it bring the same for generations to come!

—Jerry Helms

# ACKNOWLEDGMENTS

First and foremost, I must thank the Carowinds staff, especially Julie Whitted, without whom this particular book would never have been completed.

I also thank Scott Anderson, Jerry Helms, Jan Hall Brown, Meg Rallings, James Henderson, Chris Kirby, Rod Alexander, Neal Hall, and Becky Neely.

Unless otherwise noted, all images in this book come from Carowinds' archives.

# INTRODUCTION

Carowinds came into being in the early 1970s, when the burgeoning theme park industry was booming. Numerous such venues had already opened across America, while plenty of others were in development or under construction. The initial inspiration for Carowinds, however, stretches back to the 1950s, when prominent Charlotte, North Carolina, businessman and commercial real estate developer E. Pat Hall found himself intrigued by Disneyland. During a fortuitous visit to Walt's original park in California, Hall was impressed by the design and the wholesome approach to family entertainment. It was then that he began to formulate his plan to bring a similar but uniquely Carolina resort to the Charlotte area.

Hall's ambitious plan would germinate for more than a decade. During that period, he amassed a staggering degree of theme park–related research and began to surround himself with like-minded individuals who shared his values and savvy business sense. By the late 1960s, Hall had purchased several hundred acres of land a few miles south of Charlotte. He chose to build his new park on the border between North and South Carolina, a characteristic that is treasured to this day.

Carowinds opened with great fanfare in 1973, sporting original themes chosen to showcase the rich history and cultural heritage of the Carolinas. Attention to detail in every sense was addressed, and the result was a theme park like no other. Though Carowinds was immensely popular during its first years, the sagging economy of the mid-1970s directly affected attendance and forced Hall to eventually sell the park in order to save it.

Over the years, ownership of Carowinds would change hands several times. However, the park continued to grow and evolve favorably. While each operator left their own unique imprint on the venue, Carowinds still managed to retain key facets of its original identity, which reflected first and foremost its Carolina lineage. Though some of the park's rides and area names may have been altered or even replaced, the intrinsic soul of Carowinds remains intact and completely relevant. Even in this day and age of hi-tech video games and other such activities, there is still a tactile desire, a human need to experience the sights and sounds and smells that only a visit to a real amusement park can provide.

During the research and writing of this book, I found myself quite fortunate to speak at length with many longtime Carowinds employees who shared their personal recollections. I was deeply affected by how much they truly loved something that had become such an integral part of their lives. Listening to them speak of their long years at Carowinds and hearing their memories come to life, I was whisked back to that time when the park was brand new and a bright future beckoned.

Just as I was finishing the text, I suddenly came to the realization that there was no way we would be able to include each and every ride, attraction, show, or event that has operated or taken place at Carowinds. Not only were there time and space constraints but I also become conscious of the fact that the representation of this amazing park's colorful, multilayered saga requires far more than a single collection of photographs. With that in mind, I hope this book inspires others who have known and loved this phenomenal, one-of-a-kind, southern theme park. I hope it rekindles thoughts of the past and inspires readers to go through their own collections, to remember and then to share what they saw and experienced during their time at this extraordinary place called Carowinds.

# One

# CAROWINDS FOUNDER
# E. PAT HALL

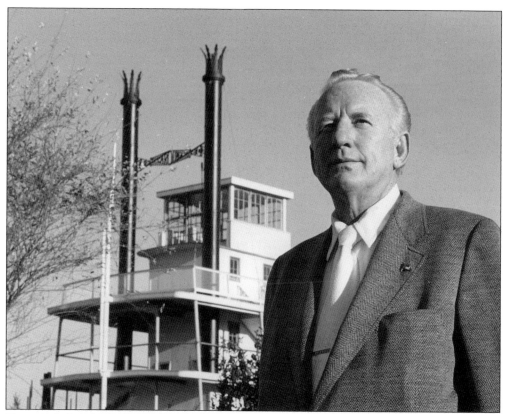

Carowinds founder E. Pat Hall looks forward with the Carolina Sternwheeler just behind him. It took many people, years of planning, and millions of dollars to construct Carowinds, but the park could never have been built without Hall's vision, grit, and determination.

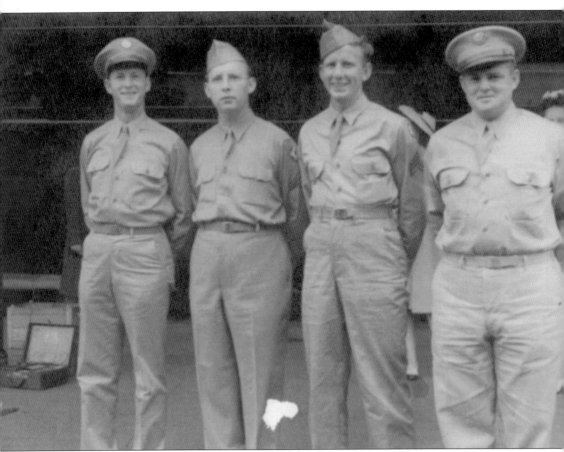

In this 1943 image, E. Pat Hall is pictured with three of his brothers—from left to right, they are Buck, Fred, Pat, and Carlton Hall—when they were on leave together to attend the wedding of their sister Ludie. Hall was one of 10 children, the sixth of seven boys, and the only one of them with red hair. According to his family, this was a constant source of ribbing among his siblings, but perhaps a formative experience in his young life, since he grew up to become a scrappy and astute businessman. (Courtesy Jan Hall Brown.)

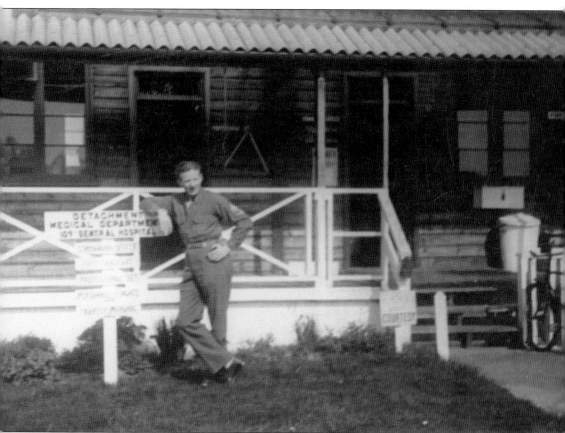

E. Pat Hall joined the Army in 1942, when he was 21 years old. He had graduated from Oakhurst High School in Charlotte, North Carolina, in 1938; he graduated after 11th grade, since he lived in Mecklenburg County (at the time, students who lived in the county graduated in 11th grade, while students from the city of Charlotte continued through 12th grade). He had a series of jobs, including working at a Belk department store, before joining the Army at the height of World War II. (Courtesy Meg Rallings.)

E. Pat Hall served in England with the 109th General Hospital. Army records state he was rated as a skilled chief clerk and first sergeant, but more telling is a letter written to Hall from his captain and dated October 9, 1945, just after the war had ended and Hall had been discharged. Hall's superior wrote: "Being a born leader of men, fearless, domineering and a man of decision you have qualified admirably as first sergeant of the 109th . . . had you lived several generations ago you would probably have been a successful and popular pirate." Years later, Hall would, in a way, fulfill that vision by creating Pirate Island at Carowinds. (Courtesy Meg Rallings.)

Myrtle Hope Pitts was born and raised in Charlotte as the fifth of seven children and the first girl. Her parents, Myrtle Sue Johnson Pitts and Thomas Lawrence Pitts, said that with four boys already, they had been hoping so much for a girl that they named their first daughter Hope. In her 20s, she worked at the *Charlotte Observer* as a women's editor. Her family described her as kind, a good mother, stylish, gracious, loyal, and a good friend. (Courtesy Jan Hall Brown.)

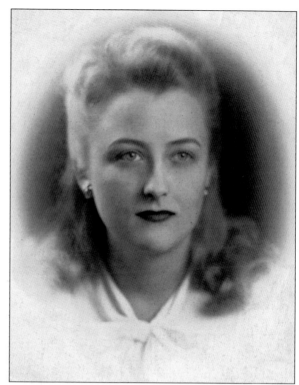

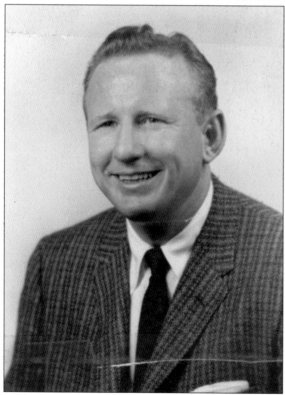

Pat Hall became a successful real estate developer, but first he formed a business that bought used machinery from textile mills shutting down in northern states, refurbishing the machines in Charlotte and then selling them to emerging markets farther south and west. On a business trip to California, he discovered Disneyland and started to think about opening a park in the Carolinas. (Courtesy Jan Hall Brown.)

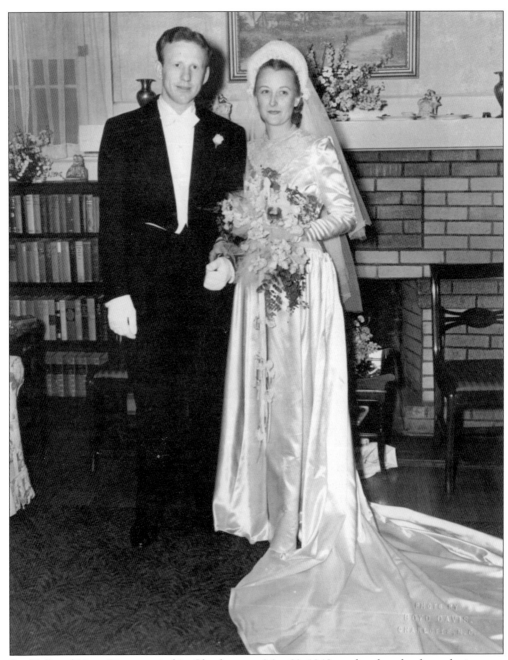

Pat Hall and Hope Pitts married in Charlotte on May 29, 1948, at the church where they met—Hawthorne Lane Methodist Church. She was 26, he was 27. They seemed to be a good match, and the two had many friends and enjoyed entertaining. She was also down-to-earth and levelheaded, helping her to keep her enterprising, fun, and fun-loving husband grounded throughout their 29 years of marriage. (Courtesy Meg Rallings.)

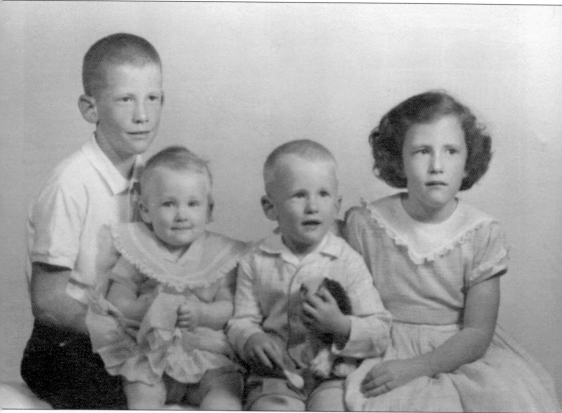

The four Hall children pictured here are, from left to right, Pat Jr., Jan, Neal, and Meg. Not long after this picture was taken, their father returned from a business trip and told them he was going to build them a park. "When our father told us he was going to do something, we just knew he was going to do it," recalls Jan. All four children ended up working at the park themselves. Pat Jr. became the entertainment manager, Jan worked in guest relations, Neal did a short stint as Ringo Raccoon, and Meg worked in the wardrobe department. (Courtesy Jan Hall Brown.)

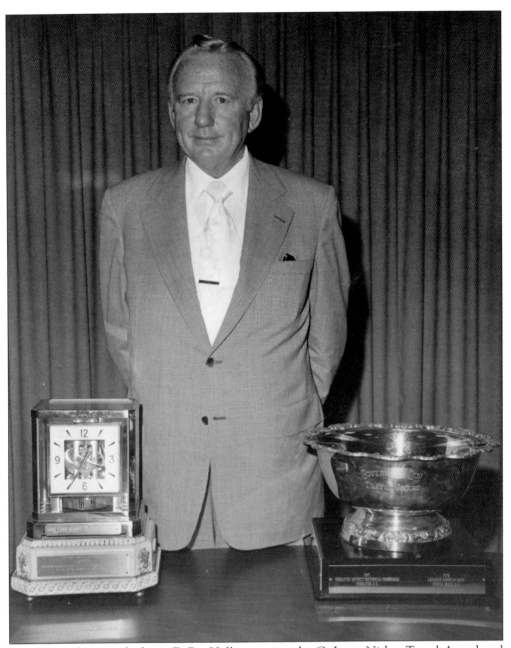

This 1970s photograph shows E. Pat Hall accepting the G. Lynn Nisbet Travel Award and Governors Travel Award from the travel councils of North and South Carolina Chambers of Commerce. The awards are given to the person or organization that contributes the most to recreation and tourism in North and South Carolina. Always a sharp dresser, Hall's signature accessory was a white tie with a gold tie clip engraved with the letters "YCDBSOYA" to represent his life motto—"You can't do business sitting on your ass."

Pat and Hope Hall are pictured here on Easter Sunday in 1977 in the last photograph taken of them together. The couple is standing next to his black Lincoln Continental; this car and Cadillacs were what Pat Hall always drove. He died a year later, in March 1978, from a heart condition. Hope passed away in 1980. (Courtesy Jan Hall Brown.)

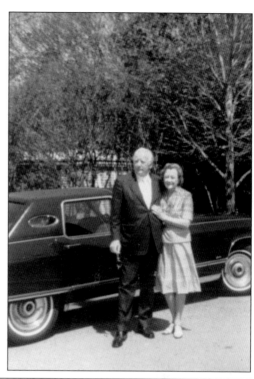

When Hall died in 1978, his death was front-page news. Creating Carowinds had elevated Hall's profile in the community—while he had developed a number of successful projects, like Arrowood Business Park, none were as fantastic and far-reaching as Carowinds. The park was mentioned in every obituary, along with his sense of humor, his love of a good party, his adventurous spirit, his business savvy, and his hard-charging ability to get things done.

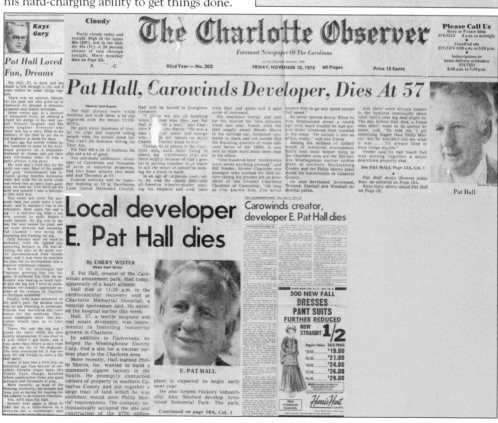

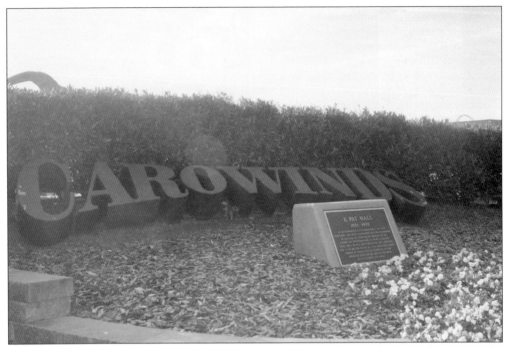

Carowinds placed this plaque at the front of the North Gate entrance to honor and recognize the achievements and contributions of founder E. Pat Hall. It says, "E. Pat Hall was an entrepreneur extraordinaire who built Carowinds for the enjoyment of millions of Carolinians. Because of his vision and determination to make a reality what most people only dream of, the Carolinas are a far better place to live. Carowinds, which opened March, 1973, is dedicated to the creed he lived by: No idea is too bold; no challenge too great."

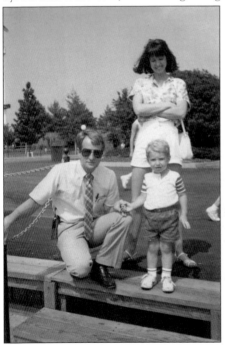

"This young man is looking for a job," stated E. Pat Hall when he brought a young Jerry Helms into his office in 1973. Helms (left), seen here with son Jon and wife Irene at the kiddie train station in 1985, started his career at Carowinds working as a security guard that first year and went on to eventually become vice president of operations. During park operation, he walks 8–10 miles per day throughout the park, going through four pairs of shoes each year. He often reflects on how different his life might have been had he not made a wrong turn and stumbled into E. Pat Hall himself (see his Foreword on page 6). In his role today, Helms works with 2,000 full- and part-time employees to keep the park safe and clean, just as Pat Hall would have wanted. (Courtesy Jerry Helms.)

# *Two*

# BUILDING THE DREAM

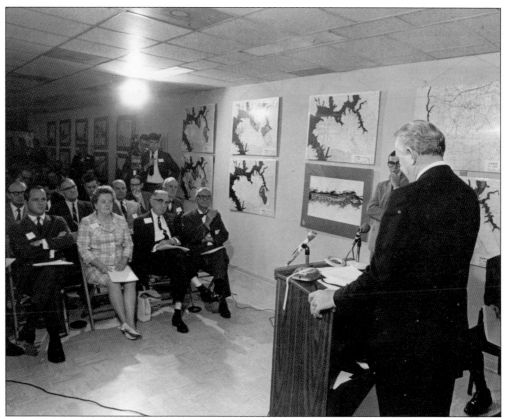

During a media conference held on October 10, 1969, E. Pat Hall (pictured at the podium) shared his ambitious plans for Carowinds with a large group of print, radio, and television reporters. Though construction began on time in early 1970, weather and other delays pushed the park's grand opening from 1972 to March 31, 1973.

This first logo prototype was used in the 1969 announcement. It changed when the park opened in 1973.

Construction of Carowinds began in early 1970 and progressed at a steady pace. Here, high-flying workers wrangle the upper sections of the park's iconic Skytower into place. The ride, designed and manufactured by Intamin AG of Switzerland, has a circular cabin that transports guests a lofty 262 feet above the midway. Behind the Skytower is a man-made hill that would soon be home to the taller sections of the Powder Keg log flume attraction.

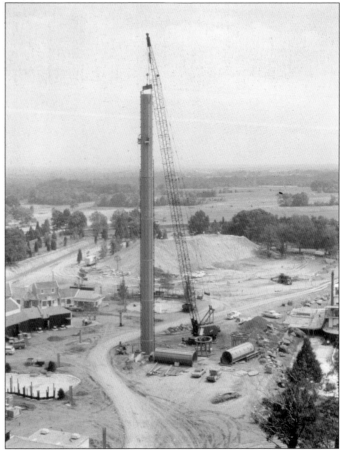

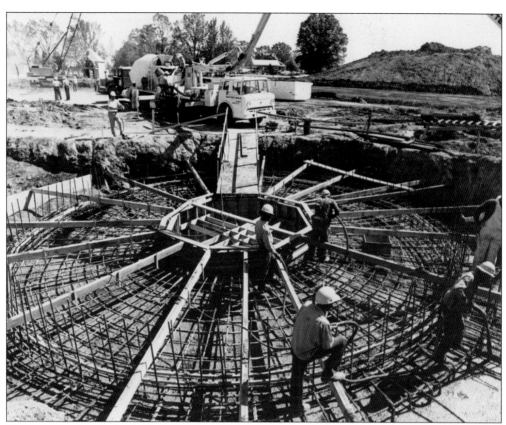

This intricate network of rebar serves as a tensioning device for the Skytower's reinforced concrete support base. It took a full 24 hours for workers to mix and pour the concrete for this important component of the Skytower, which allows the structure to withstand wind speeds up to 120 miles per hour.

Frog Creek Campground, which is located adjacent to the main park, was to feature plenty of sites with full electric, water, and sewage hookups. In this image, construction is well under way on the trading post and swimming pool.

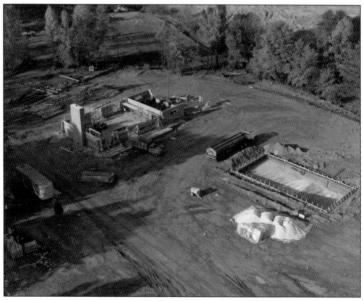

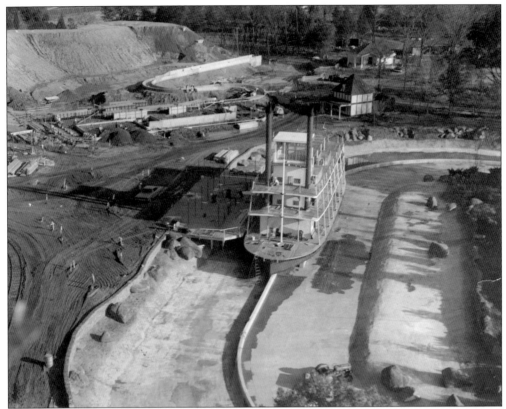

This aerial view shows the Carolina Sternwheeler in dry dock during construction. Morgan Yacht Corporation of Largo, Florida, manufactured the large paddleboat—one of the park's original attractions. Although the craft appeared to be free-floating, in reality, it was fully controlled by an underwater guide rail, which is clearly visible below the boat's bow. At upper left, the log flume's concrete trough and boarding platform are beginning to take shape.

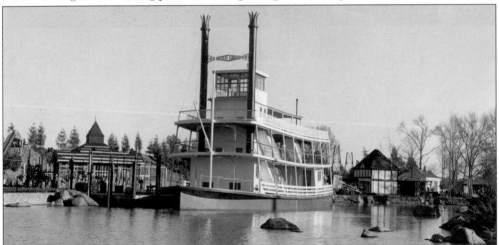

With Carolina Lake filled in, the tri-level Carolina Sternwheeler is moored at its landing in Plantation Square. Outfitting and other cosmetic enhancements are under way on the boat as the grand opening of Carowinds quickly approaches.

During filming for a television segment about the construction of Carowinds, E. Pat Hall (left) walks with WBTV reporter Bill Ballard while camera operator Dave Clanton captures the action. This image is from late winter 1973, and the location is the boarding station walkway for the Powder Keg log flume.

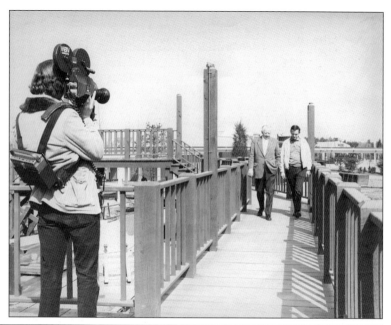

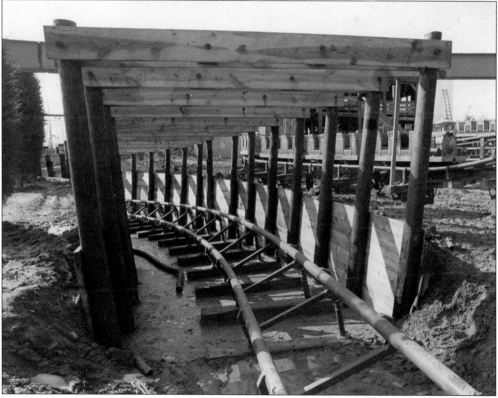

This early 1973 image shows the Goldrusher mine train as the coaster enters the final stages of construction. This view depicts the tubular steel track in a below-grade section of the course that riders encounter just before the train engages the second lift hill. In the background, a complete train approaches the base of the first lift hill while another rests on the transfer track.

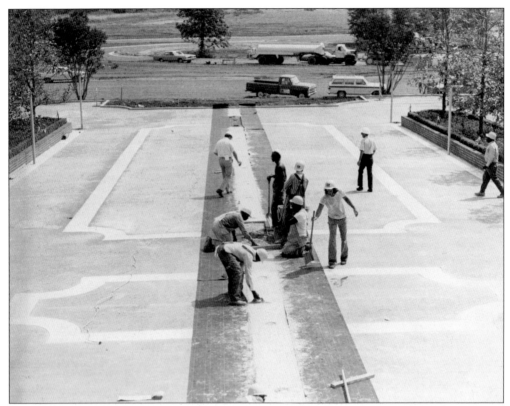

These workers are literally working on the North Carolina/South Carolina state line. This 100-yard strip of golden concrete marks the place where the border of the two Carolinas passes through the entrance to Carowinds. Initially, incandescent lights and small bronze plaques engraved with the names of the 146 counties in the two states were embedded in the line.

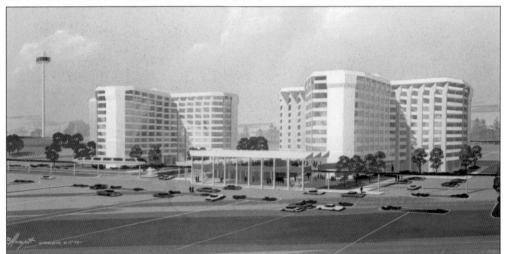

This early concept drawing shows the high-rise hotels (complete with their own monorail station) that were envisaged for a later phase of the Carowinds master plan. Though this part of E. Pat Hall's dream did not materialize, the park's monorail did travel outside of the park proper and toured the proposed site alongside Interstate 77.

# On March 31st, the largest family entertainment park in five states will open some eyes.

Wide-eyed fantasy is what Carowinds is all about. And starting March 31st, Carowinds will provide more eye-opening excitement for you and your family than any other entertainment park in the Southeast. Carowinds has jam-packed over 100 thrilling attractions into 73 sprawling acres on the North and South Carolina state line. So come visit. And let us open your eyes to the most fun you'll have anywhere. Open weekends, 10 A.M. Camping facilities available. Adults $5.75, children 12 and under $4.50, 3 and under, free. Monorail tours, 75¢ I-77 South. Charlotte

All the fun of North and South Carolina put together

## CAROWINDS

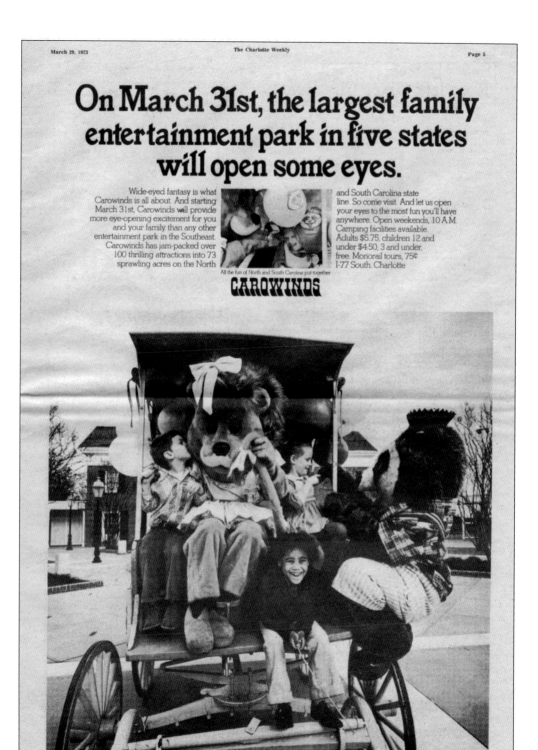

This full-page advertisement appeared in the *Charlotte Weekly* on March 29, 1973, just two days before the much-anticipated Carowinds debut. Here, children pose in a horse-drawn buggy with Carolion, one of the park's early mascots.

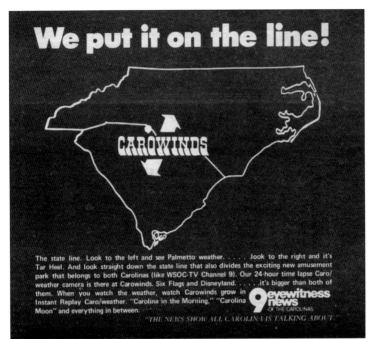

The state line. Look to the left and see Palmetto weather. . . . . .look to the right and it's Tar Heel. And look straight down the state line that also divides the exciting new amusement park that belongs to both Carolinas (like WSOC-TV Channel 9). Our 24-hour time lapse Caro/ weather camera is there at Carowinds. Six Flags and Disneyland. . . . .it's bigger than both of them. When you watch the weather, watch Carowinds grow in Instant Replay Caro/weather. "Carolina in the Morning," "Carolina Moon" and everything in between.

**9 eyewitness news** —OF THE CAROLINAS

*"THE NEWS SHOW ALL CAROLINA IS TALKING ABOUT."*

The opening of Carowinds was big news in both North and South Carolina. Charlotte's WSOC-TV Channel 9 offered plenty of coverage of the big event, including around-the-clock televised reports and the 24-hour instant replay Caro/ weather camera at the park itself.

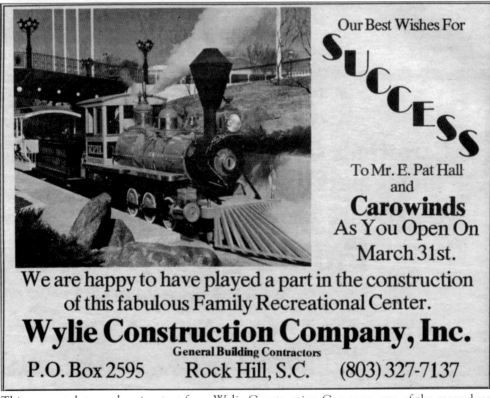

This congratulatory advertisement from Wylie Construction Company, one of the many local contractors that helped build the park, featured a great shot of E.P.H. (E. Pat Hall) Engine No. 1 from the park's beloved Carowinds & Carolina Railroad.

26

*Three*

# THE FIRST YEARS

This picture was taken on March 30, 1973—the day before the grand opening of Carowinds. Major construction is complete, and most of the park is ready. This view illustrates what arriving guests will see as they step through the main gate at the Plantation House and emerge into the Court of the Carolinas. The white state line is visible and stretches horizontally through the image. The automobile toll plaza is visible in the upper left corner, while the loop of asphalt at the top of the photograph is the roadway used by trams that shuttle guests from the parking area to the ticketing center.

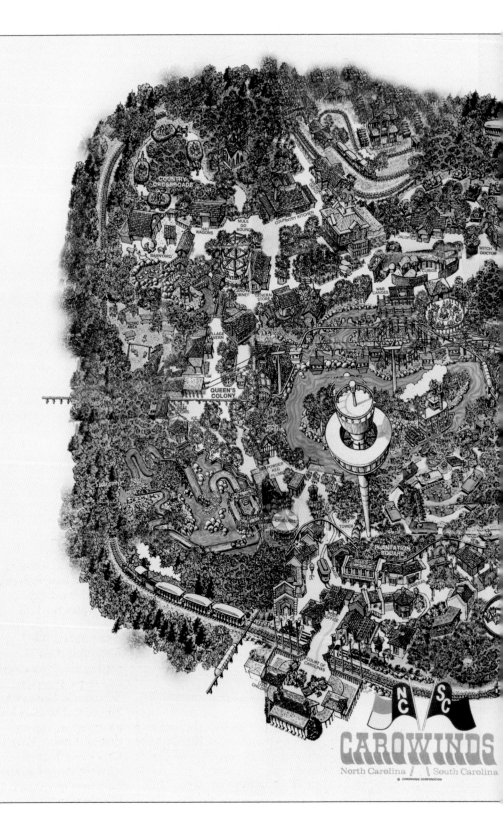

COUNTRY CROSSROADS

HAY WAGONS

MULE GO ROUND

COUNTRY KITCHEN

JALOPIES

WITCH DOCTOR

CURIOS

BARNYARD

CANDY CORNER

GENERAL STORE

WAR CANOES

PICNIC AREA

VILLAGE TAVERN

QUEEN'S COLONY

POWDER KEG CLIMB

CAROUSEL

SKY TOWER

PLANTATION SQUARE

OFFICE

COURT OF CAROLINAS

CHILDREN

**NC** **SC**

# CAROWINDS

North Carolina ⫽ South Carolina

© CAROWINDS CORPORATION

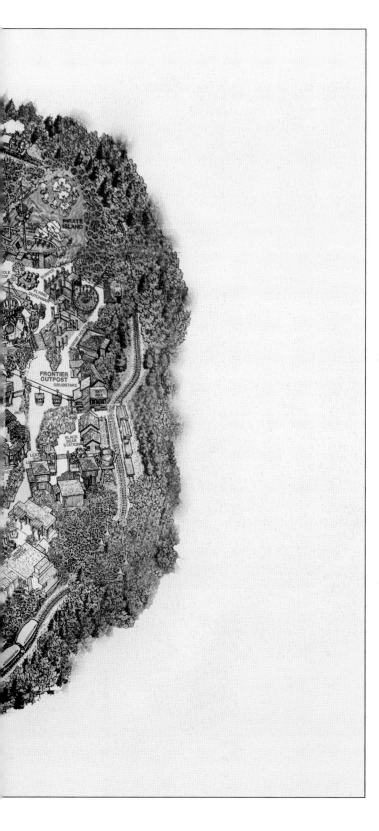

This map shows Carowinds as it looked in its first year, featuring seven themed areas that represented the history of the Carolinas. The park was filled with rides, theaters, a petting zoo, restaurants, and shops. From the Skytower in Plantation Square and heading left, a map viewer can see Queen's Colony, Country Crossroads, Indian Thicket, Pirate Island, Frontier Outpost, and the Contemporary Carolinas.

Eleven-year-old Jimmy Henderson had the honor of being Carowinds' first official visitor. According to the *Charlotte Observer*'s report about the day, "Jimmy proudly lifted the velvet rope that closed off the walkway into the park and balloons climbed slowly into the gray haze. Carowinds was officially open." Henderson grew up to become an attorney in Charlotte and fondly remembers that rainy first day at Carowinds. (Courtesy James Henderson.)

Reporters and visitors gather around the podium to hear Pat Hall share the story of young Jimmy Henderson, who trapped rats at his uncle's dog kennel to earn money for the outing. Henderson wrote in a Carowinds scrapbook: "Everyone eager to take my picture. I drip rain trying to live down Mr. Hall telling the crowd about my rat trapping." (Courtesy James Henderson.)

North Carolina / \ South Carolina

December 19, 1972

Master James Henderson

Dear Jimmy:

We appreciate so much your interest in Carowinds and your request to have our "first ticket". Since your letter was the first we received with this request, we are going to send you our very first ticket to Carowinds.

The tickets have not yet been printed, but just as soon as they are, we will be sending your ticket to you. We are progressing rapidly with our park and are all anticipating eagerly Saturday, March 31, when we will open. We hope you can be with us on our opening day.

Thank you again for your interest in our Park and we are looking forward to seeing you soon.

Sincerely,

E. Pat Hall

In his letter that started it all, Jimmy Henderson, eager to visit Carowinds, wrote to Pat Hall months in advance of opening day. In this reply, Hall confirmed that the 11-year-old from Charlotte would be the lucky first visitor. (Courtesy James Henderson.)

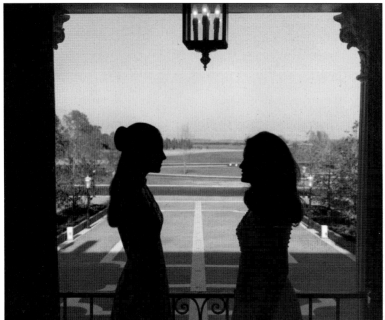

Preparing to greet the first guests who will soon arrive, 1972 Miss America contestants Miss North Carolina (Constance Dorn, left) and Miss South Carolina (Bonnie Corder, right) face off across the state line upon the balcony of the grand Plantation House at Carowinds' main entrance.

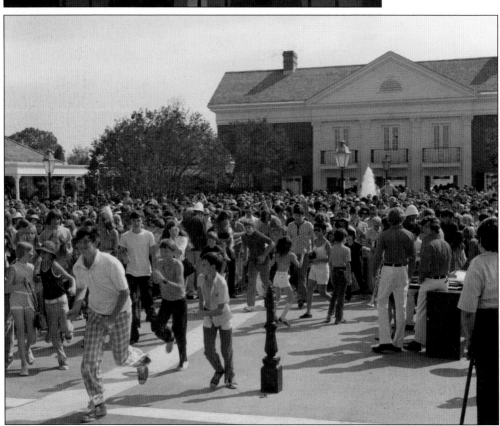

And they are off! Carowinds began daily operations on June 2, 1973. A massive crowd numbering more than 3,000 fills the Court of the Carolinas on a sunny Saturday morning.

In its first years, Carowinds' Skytower was sponsored by Eastern Airlines and branded as the Ionosphere Tower. This designation was a nod to the Ionosphere Club, the air carrier's exclusive airport lounge at the nearby Charlotte/Douglas International Airport, where Eastern operated a major hub.

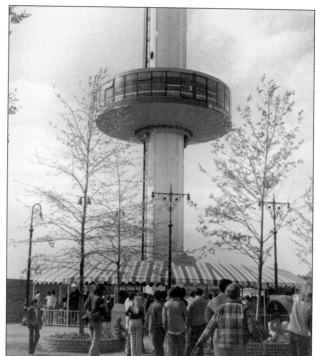

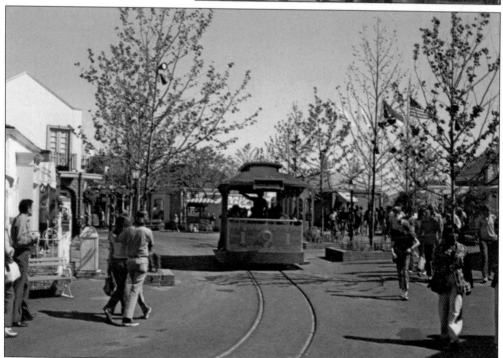

The Carowinds Interstate Trolley Line is pictured passing through Plantation Square. According to the caption on this postcard, the intent of the attraction was to "recreate an 1880s street scene." In reality, this short-lived feature was yet another example of the influence of Disneyland on Carowinds' founding father, E. Pat Hall.

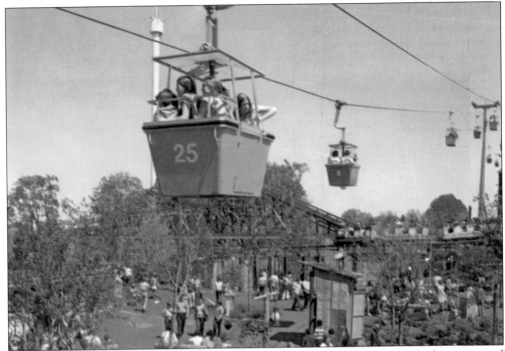

One of the best ways to see Carowinds was the 1,000-foot-long Cable Skyway, which transported guests on a gentle flight from the Frontier Outpost to the Queen's Colony section of the park. A product of the Swiss firms Intamin and Giovanola, this attraction, once a staple at many theme parks, has become an endangered species. The Cable Skyway was removed in 1983.

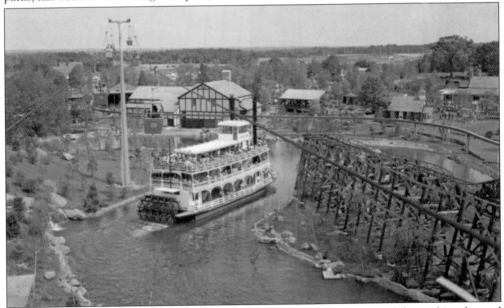

From the Cable Skyway, guests could catch a spectacular view of many of the park's rides and attractions. The Goldrusher mine train's drop off the second lift is at right, while the Carolina Sternwheeler chugs back toward its dock in Plantation Square. The gray monorail track travels along the water's edge.

34

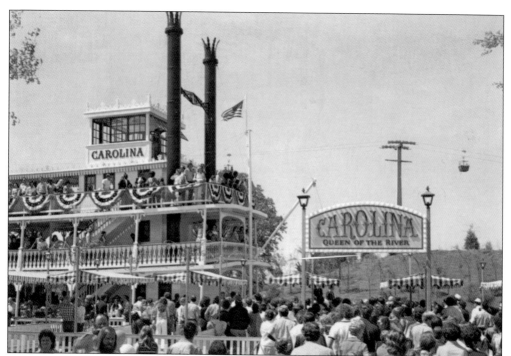

The "Queen of the River" accommodated up to 330 passengers for a 10-minute cruise around Carolina Lake. An authentic Dixieland band often provided onboard entertainment, playing tunes made famous during the Roaring Twenties.

A favorite of older visitors and families with small children due to its leisurely pace, the Carolina Sternwheeler entertained guests for 30 seasons. It and much of the lake were removed in 2003 to allow for the installation of the BORG Assimilator (now the Nighthawk) roller coaster.

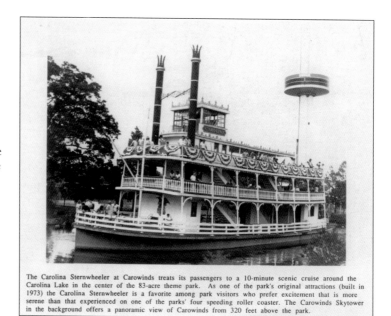

The Carolina Sternwheeler at Carowinds treats its passengers to a 10-minute scenic cruise around the Carolina Lake in the center of the 83-acre theme park. As one of the park's original attractions (built in 1973) the Carolina Sternwheeler is a favorite among park visitors who prefer excitement that is more serene than that experienced on one of the parks' four speeding roller coaster. The Carowinds Skytower in the background offers a panoramic view of Carowinds from 320 feet above the park.

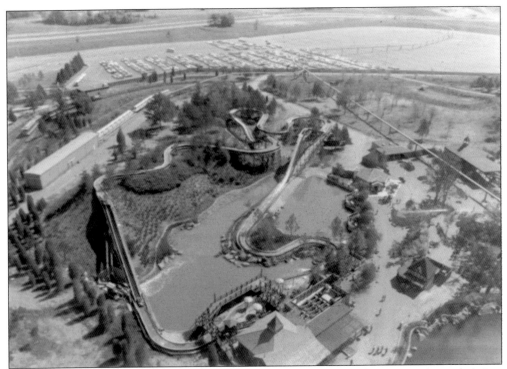

The Powder Keg log flume, located in Queens Colony, was one of the major rides included in Carowinds' opening season in 1973. It was supplied by Arrow Development and featured two lifts. The foliage eventually grew up around the trough, enhancing the experience as guests "floated" above and through the trees.

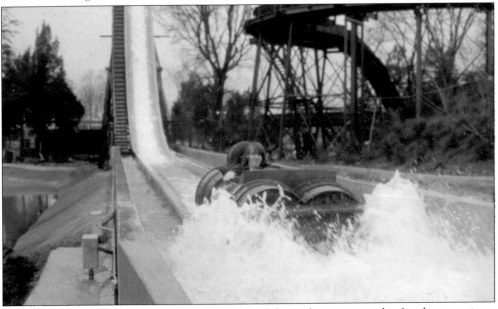

For decades, the Powder Keg log flume was one of the park's most popular family attractions, especially on hot summer days when the resulting splashdown provided guests with a perfect way to cool off. On busy days, the dual-loading station kept the queues moving in a brisk manner.

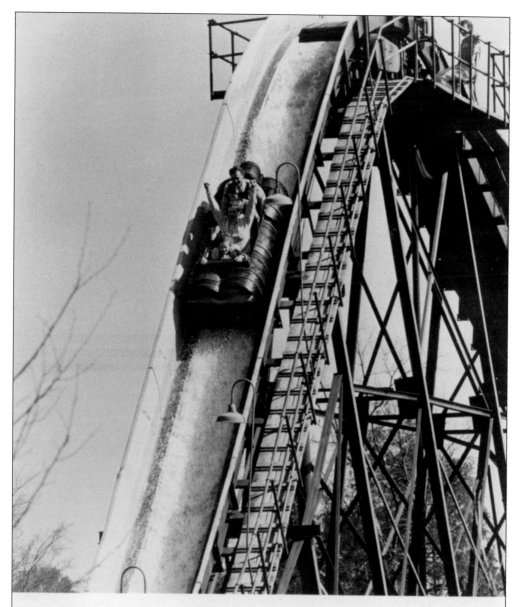

A 45-ft. plunge down a water trough and a splash landing add to the thrill of the Powder Keg Flume ride at the Carowinds theme park. The flume drop is one of the highest in the country. Carowinds, in its third year of operation, is expected to attract 1.2 million persons during the 1975 season.

Four guests brave the final 45-foot plunge on Carowinds' Powder Keg log flume. The popular ride remained in operation until it was closed and removed to accommodate the installation of Intimidator, a hypercoaster that opened in 2010.

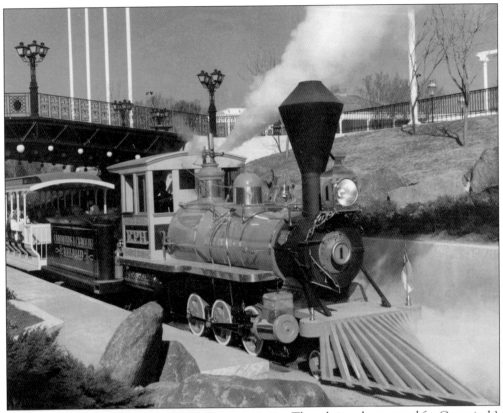

Though it only operated for Carowinds' first five seasons, the 36-inch narrow gauge Carowinds & Carolina Railroad was extremely popular with guests. Engine No. 1 carried the letters "E.P.H." (E. Pat Hall) on the right side of the cab and "Melodia" on the left—a name that it received during the early 1900s as a work train on Louisiana sugar plantations. Here, it waits for passengers in the Plantation Square Depot, which was located under the bridge that guests used to enter the park.

Just before coming to Carowinds, Engine No. 1 rode the rails of the Daniel Boone Railroad in Hillsborough, North Carolina. At its new home, it joined another steam locomotive (Engine No. 2) hauling passengers along a route that utilized three different stations as it circled the park. Today, "Melodia" can be found steaming along the rails of California's Pacific Coast Railroad.

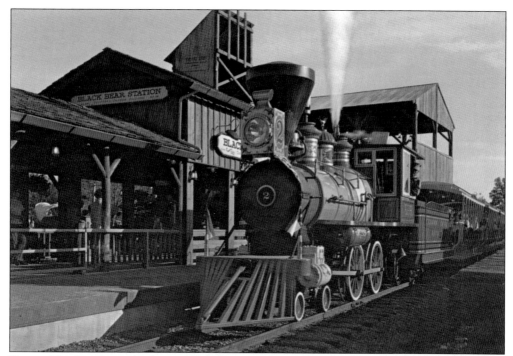

Engine No. 2 prepares to depart Black Bear Station in the Frontier Outpost. Carowinds had the passenger coaches specifically built for the Carowinds & Carolina Railroad. These open-air vehicles provided guests with a refreshing tour of the park. Singer Michael Jackson eventually purchased Engine No. 2; he renamed it "Katherine" for his mother and operated it for several years at his Neverland Ranch.

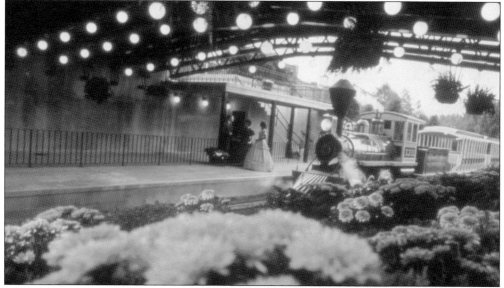

Carowinds associates decked out in proper Southern attire await the arrival of "Melodia" as she pulls into the Plantation Square depot. The park's expert use of appealing landscaping and soft lighting harked back to simpler times when rail travel was the norm. This area now serves as a maintenance roadway.

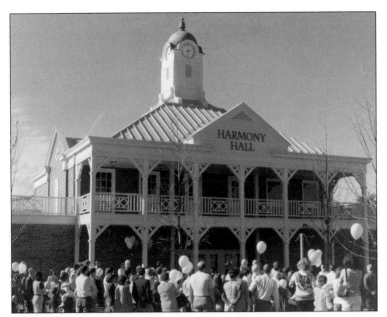

Located in Country Crossroads, Harmony Hall offered a large number of musical variety shows featuring high school and college performers from the Carolinas and surrounding states. The venue could accommodate up to 600 guests per show.

For some of these young artists, performing at Harmony Hall (and the Magic Theater located across the park) offered them a first chance to be on stage before a live audience. Even at their young ages, they quickly became professionals.

Each show featured choreographed numbers with spirited singing and dancing as well as expertly crafted costumes, set design, and theatrical lighting. These creative shows were often performed seven times each day and seven days each week for the entire summer.

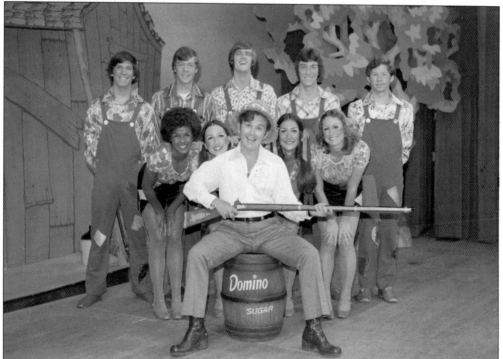

Outside sponsorship and product placement found a place in early Carowinds productions. This photograph seems to indicate that Domino Sugar backed the popular country hoedown show, which remained a guest favorite for several seasons.

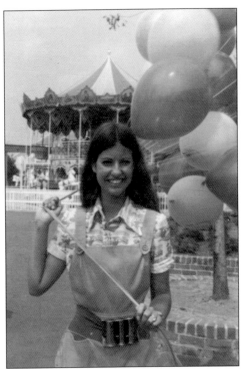

From the start, "balloon girls," who strolled through the park with enormous bunches of colorful balloons that cost 50¢ each, were a popular mainstay at Carowinds. Guests often asked the girls to pose with them for photographs. Balloon girl Irene Waterman is pictured here in 1973 in front of the park's first carousel; she dated and eventually married then security guard Jerry Helms, who is now the vice president of operations at Carowinds.

The first carousel at Carowinds was an ornate, 100-year-old double-decker model imported from Germany. In this photograph, it is shown under construction. For the park's first two seasons, this beautiful machine operated adjacent to the Powder Keg log flume in Plantation Square. After remaining in storage for several years, it was eventually donated to its first home, the town of Dreieichenhain in Hesse, Germany, in the fall of 1979. After a complete restoration, including having new horses carved, it still operates there today.

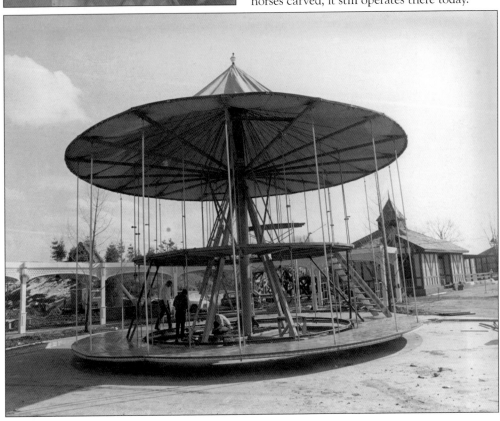

Blackbeard's Hold featured a gift shop within where guests could climb to the top deck and use cannons to fire at targets in the water. In 1974, the boarding plank was removed and the ship was moved away from shore. It then became the "monkey boat"—for a couple of years, several monkeys entertained visitors by swinging on ropes.

The Hillbilly Jalopies, situated at the edge of the Country Crossroads section, were gasoline-powered antique cars created by Arrow Development. The cars, driven by guests, meandered thorough a partially wooded area. The Hillbilly Jalopies were removed to accommodate White Water Falls, which opened on the same site in 1988.

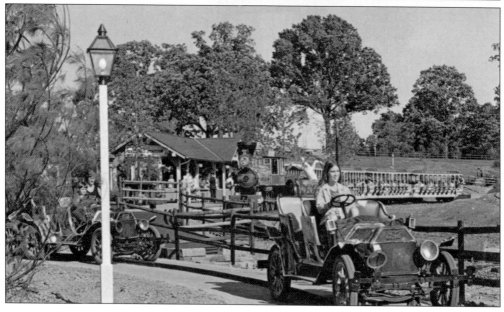

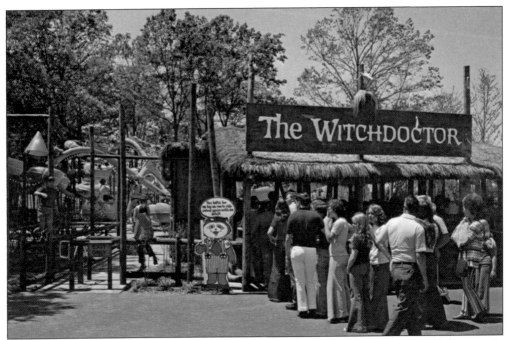

Another of Carowinds' original attractions, the Witchdoctor, was a spinning, undulating ride manufactured by Eyerly Aircraft Company under the trade name "Monster." The ride featured six arms from which were suspended four two-seat tubs, giving Witchdoctor a capacity of 48 guests per cycle.

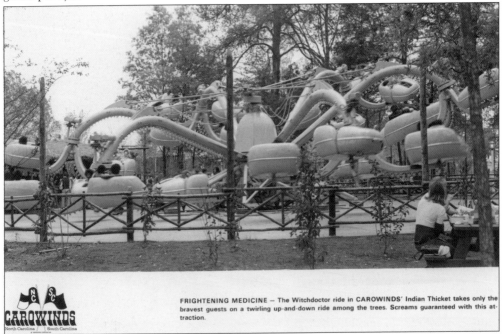

FRIGHTENING MEDICINE — The Witchdoctor ride in CAROWINDS' Indian Thicket takes only the bravest guests on a twirling up-and-down ride among the trees. Screams guaranteed with this attraction.

The Witchdoctor originally sported a light-blue color scheme but was later moved a short distance to Pirate Island, repainted black, and renamed the Black Widow. It thrilled riders until 1989, when it was removed and sold to another operator.

The Surfer, one of the original thrill rides that opened in 1973, was a highlight of the Pirate Island area and a tamer version of a notorious portable attraction known as the Tagada, which can still be found at traveling shows in Europe. Longtime park employees recall that the ride's constant spinning action required numerous "cleanups." Carowinds removed the Surfer at the end of the 1976 season.

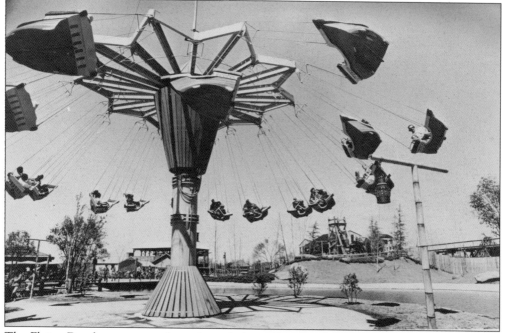

The Flying Dutchman, a popular swing ride located in Pirate Island, opened in 1973. The 14 galleon-shaped gondolas accommodated two guests each and gave them a high-flying adventure that was partially over water. The ride operated through the 1984 season.

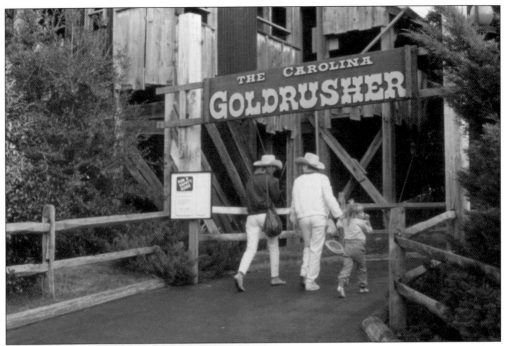

The Carolina Goldrusher, Carowinds' first roller coaster, opened in 1973. It was designed by Arrow Development, the same California-based firm that supplied a number of Carowinds rides and many of Disneyland's first attractions.

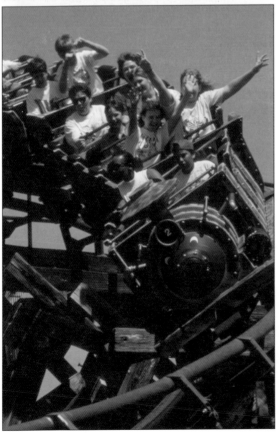

The Goldrusher is a mine train–style steel roller coaster that features 2,397 feet of tubular steel track and two lift hills. The attraction serves as a perfect transition ride as younger guests graduate from its gentle drops, turns, and spirals to the park's larger, more intense coasters.

Although it is technically a steel coaster, the Goldrusher's tubular steel track is supported by rough-hewn wooden timbers that help reinforce its rustic appearance.

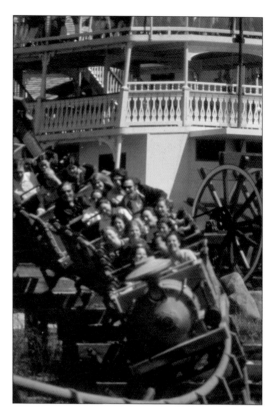

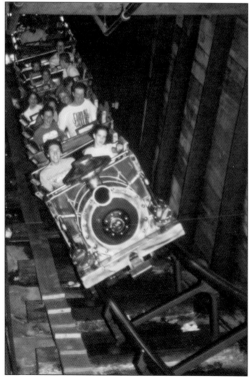

The Goldrusher's finale included a surprise drop into a hidden underground tunnel. This rare view shows the speeding train deep in the darkness as it negotiates a banked section of track that will lead it up and into the brake run.

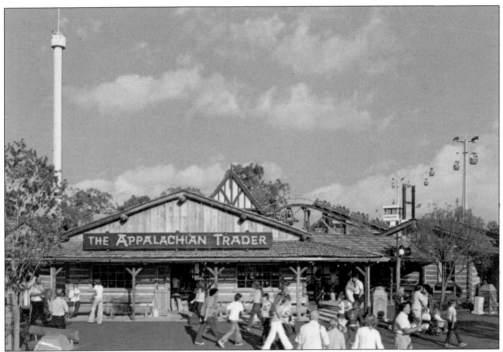

Retail is an important aspect of the theme park experience. The Appalachian Trader was one of many souvenir shops in the park. This particular store offered crafts and other specialty items produced by people hailing from various Carolina mountain towns.

In addition to the rustic offerings available at the Appalachian Trader, this shop provided guests with a number of more contemporary selections such as film, sunglasses, and stuffed animals.

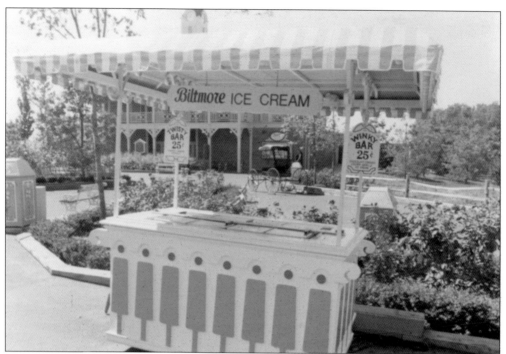

Guests require sustenance to keep dashing from ride to ride, and Carowinds offers a plethora of dining options. This particular kiosk, located near Harmony Hall, featured Biltmore Ice Cream, which included the curiously named Winky Bar and Twisty Bar; guests often found the 25¢ price tag difficult to resist.

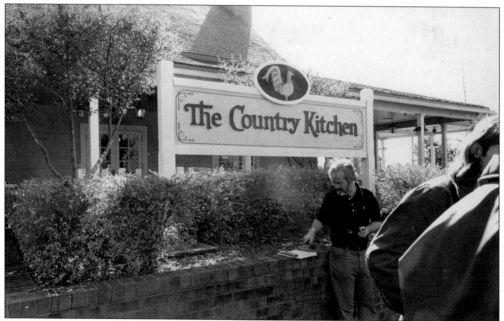

Since its debut in 1973, the Country Kitchen has remained one of Carowinds' most popular sit-down restaurants. For 40 years, this indoor, air-conditioned venue has served traditional Southern fare such as fried chicken, hand-pulled barbecue, and turkey legs.

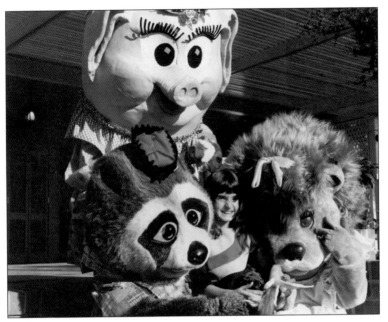

Some of the original Carowinds costumed characters included Pamela Pig, Ringo Raccoon, and Carolion. This unidentified young visitor seems completely delighted to be in their company. The characters would stroll around the park, entertaining guests and posing for what could become cherished photographs of their Carowinds visit.

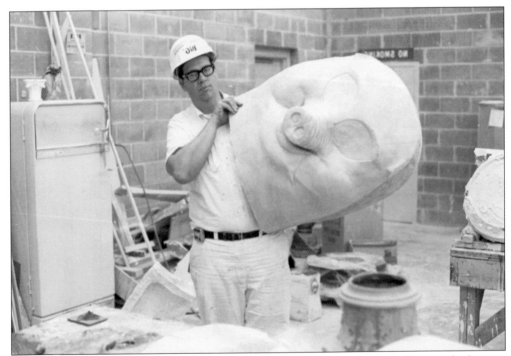

Instead of outsourcing the creation of the park's characters to a contractor, Carowinds chose to design and manufacture the costumes in-house. Here, Carowinds artist Jim Curtis works to perfect the Pamela Pig character's gigantic headpiece.

Ringo Raccoon waves to Carowinds visitors. This costumed character was one of the more popular and appeared in many publicity photographs promoting the opening of the park.

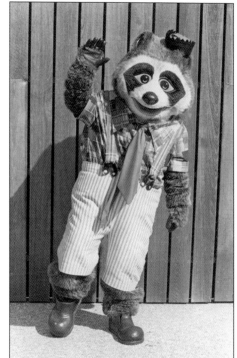

Miss America contestants Miss South Carolina (Bonnie Corder, left) and Miss North Carolina (Constance Dorn, right) pose outside Sir Walter's Smoke Shop with the lovable costumed character called Hercules. The Hall family kept a number of St. Bernard dogs as pets, and this particular character was named for one of their beloved canines.

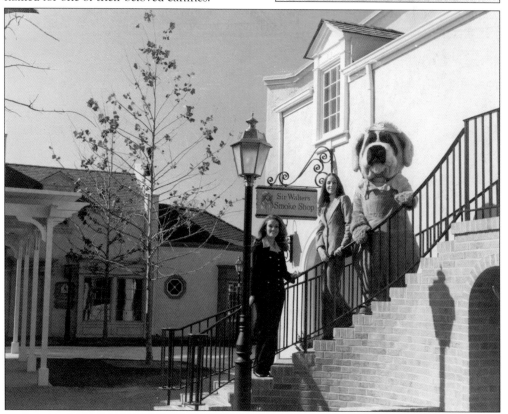

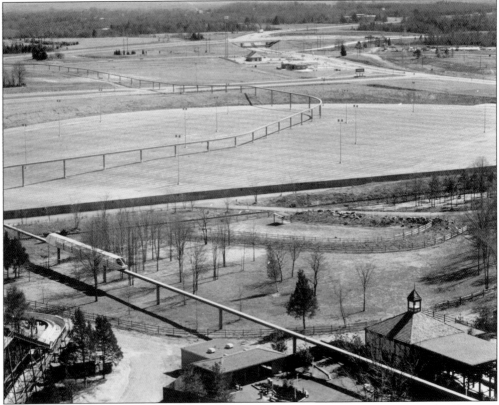

The Carowinds monorail opened to the public on June 2, 1973. This aerial view from the Skytower illustrates how the monorail traveled outside of the park proper. The section of track in the upper left corner of this photograph is where the track parallels Interstate 77; that area was originally scheduled to be a second station that would serve a pair of luxury hotels.

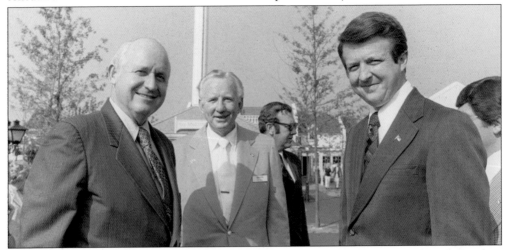

On the day the monorail opened, E. Pat Hall (center) was joined by the governors of South Carolina (John Carl West, left) and North Carolina (James Eubert Holshouser Jr.). At first, the monorail cost a separate admission of 75¢ for a tour on its two miles of elevated track. This practice was dropped in 1974, and the ride was included with regular park admission.

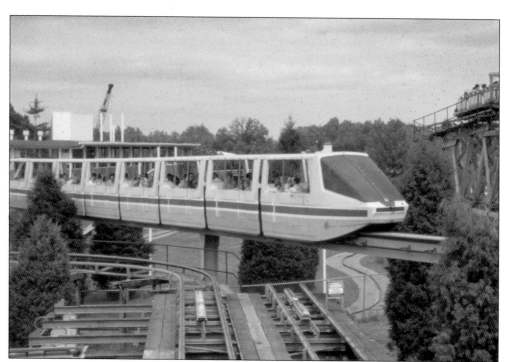

Here, the six-car monorail train crosses over the main line and the transfer tracks of the Goldrusher. A section of the Goldrusher's second lift hill structure (at left) had to be modified to allow for adequate clearance so the monorail trains could safely pass through.

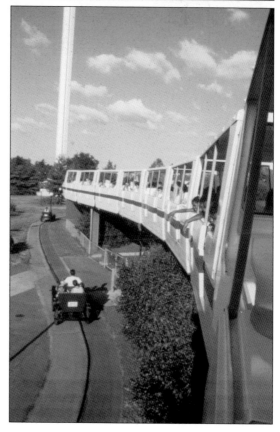

The monorail's sole station was located in Contemporary Carolina. This elevated, two-story structure played double duty as the monorail boarding platform on the upper level and the entrance and queue for the Sports Car ride on the ground floor. Due to a lack of patronage and a need for park expansion, the monorail was closed at the end of the 1994 season and sold to Preferred Vacations, Inc., which planned to relocate it to a resort in Acapulco, Mexico.

While E. Pat Hall had big dreams, his innate business sense told him when it was time to face reality. Just as Carowinds was finding its feet, the United States was rocked by the Mideast oil crisis that began in October 1973. The OPEC embargo resulted in gas rationing and related economic hardships that had a direct impact on park attendance. Hall and the Carowinds Corporation operated the park through the 1974 season but decided to sell it in hopes that a new operator with deeper pockets could continue the vision.

## Four

# THE TAFT/KECO YEARS

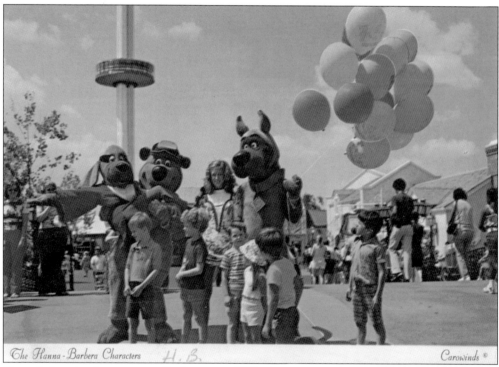

The Hanna-Barbera Characters    H. B.    Carowinds ®

Carowinds gained a new overall identity in 1975 when it was purchased for $16 million by the Ohio-based Family Leisure Centers, a joint venture of Taft Broadcasting Company and the Kroger Company. Taft also operated Kings Island, a theme park located north of Cincinnati that opened in 1972 after its predecessor, the legendary Coney Island on the Ohio River, closed in 1971. Since Taft also owned Hanna-Barbera Productions, Inc., the new owners brought a recognizable brand to Carowinds in the form of beloved cartoon characters such as Underdog, Yogi Bear, and Scooby-Doo.

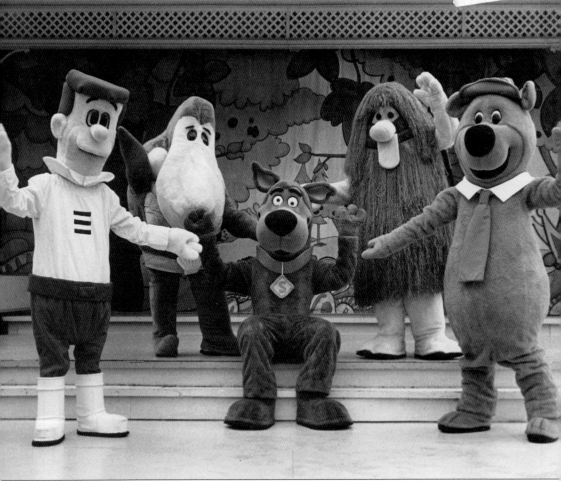

Seemingly overnight, Carowinds became home to Scooby-Doo, Yogi Bear, the Flintstones, the Banana Splits, and others. Pictured here are Hanna-Barbera favorites George Jetson, Jabberjaw, Scooby-Doo, Captain Caveman, and Yogi Bear. While Carowinds is the focus of this particular image, these same lovable characters also entertained and interacted with guests at sister parks Kings Island (which opened in Ohio in 1972) and Kings Dominion (which opened in Virginia in 1975). Over the next 15 seasons, Carowinds grew and matured amazingly well. Under the expert guidance of Taft Broadcasting and its successor, Kings Entertainment Company (KECO), the park became established as a major player in the regional theme park arena.

The new owner of Carowinds heavily invested in the park over the next few years. Taft Broadcasting continued to add new rides and attractions that appealed to younger visitors, including this junior version of the Skytower. Like its big brother, the Kiddie Skytower was manufactured by Intamin and branded by Eastern Airlines.

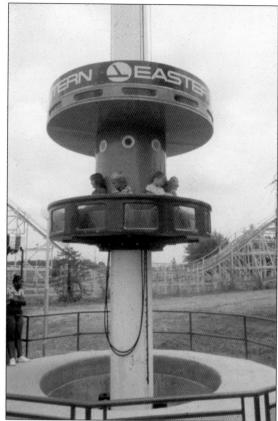

The Dastardly and Muttley Flying Machines was another pint-sized ride. Manufactured by Chance Rides, this gentle, spinning attraction allowed young pilots to take to the skies in their own biplanes. It still exists today as Snoopy vs. Red Baron.

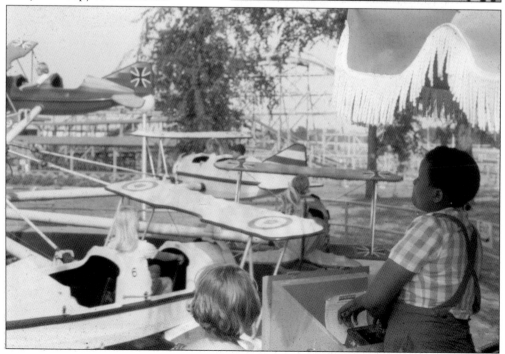

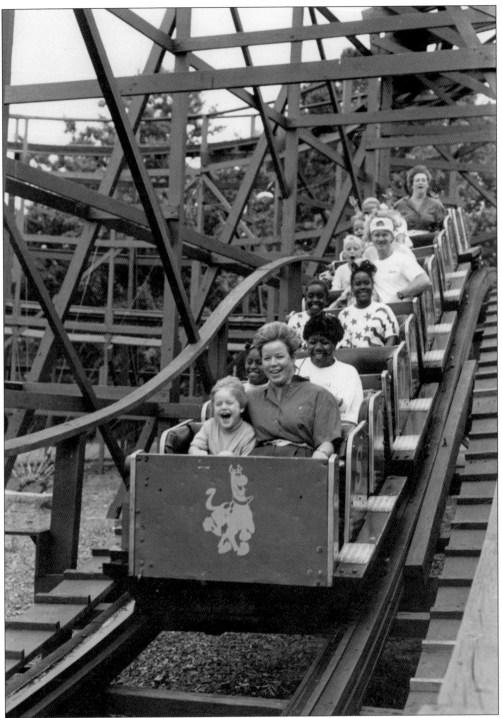

Scooby-Doo, the park's first wooden roller coaster, opened in 1975 and anchored the new Hanna-Barbera section. Designed by John Allen of Philadelphia Toboggan Company, Scooby-Doo was based on a design that was used at a number of Carowinds' sister parks, including Kings Island, Kings Dominion, and Canada's Wonderland.

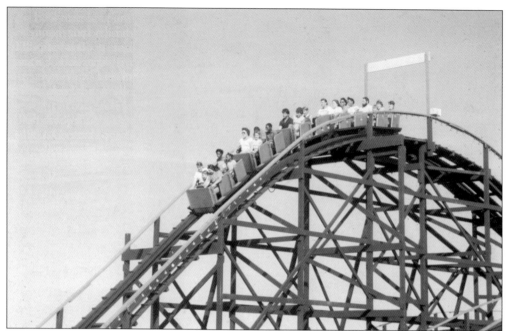

Scooby-Doo stands 35 feet tall and features 1,356 feet of track that was originally painted yellow with red rails. Here, one of the coaster's five-car trains is filled with excited passengers about to plunge down the first drop.

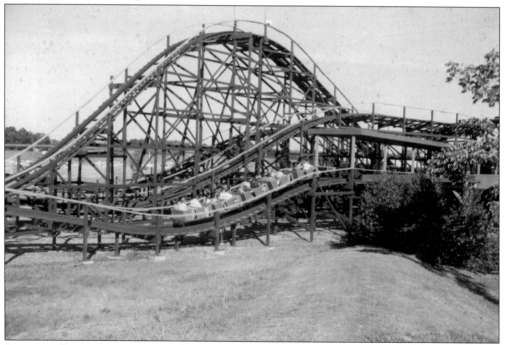

Despite its diminutive stature, Scooby-Doo consistently offers a thrilling and smooth ride experience due to being well-designed and carefully maintained. Wooden coasters, by nature, require near-constant attention to keep them in top shape. Here, the train completes the last drop before hitting the brake run. The ride continues to thrill visitors as the popular Woodstock Express.

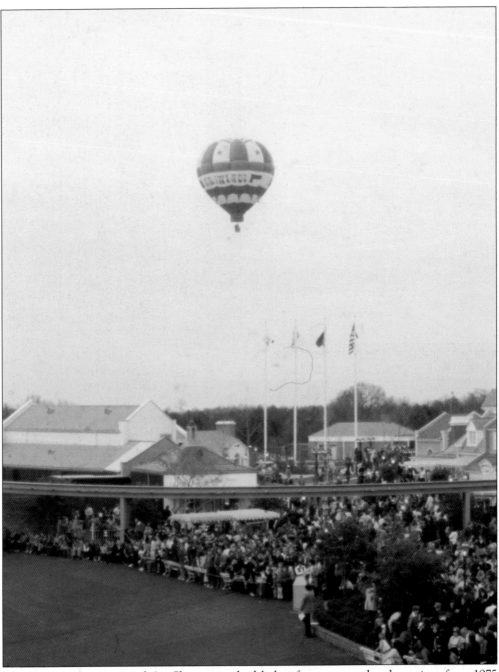

The Firestone International Air Show was a highlight of summer weekend evenings from 1975 through the early 1980s. Along with the spectacular red, white, and blue hot air balloon emblazoned with the Carowinds logo, the show featured biplanes, skywriters, and other aerial acrobatics.

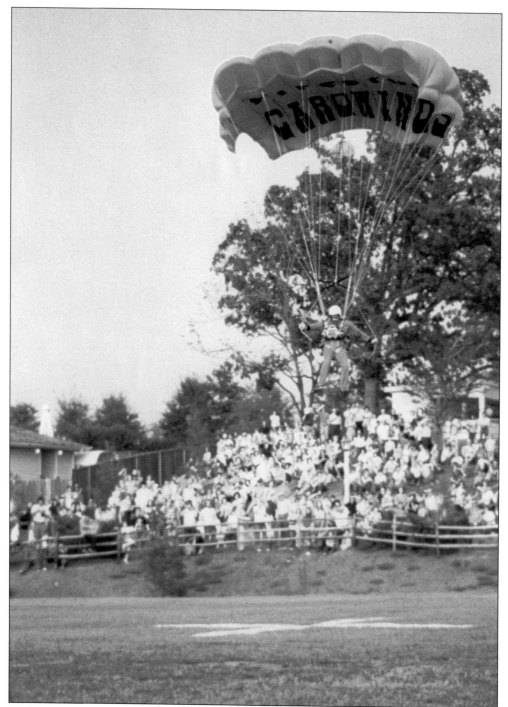

A team of skydivers was another entertaining facet of the Firestone International Air Show. Here, guests watch as an expert parachutist aims for his mark on the lawn. Longtime employees humorously recall how this did not always go as planned, and they sometimes had to send crews out to retrieve wayward skydivers who touched down somewhere other than the park's intended landing zone.

Another ambitious expansion project in 1975 was the construction of the Paladium, a 7,000-seat concert venue meant to attract top performers. The Paladium opened on Memorial Day weekend in 1975 and immediately lived up to expectations. Some of the biggest names who performed during that first season include Frankie Valli, Chubby Checker, Linda Ronstadt, the Righteous Brothers, Ray Stevens, Neil Sedaka, and Tanya Tucker.

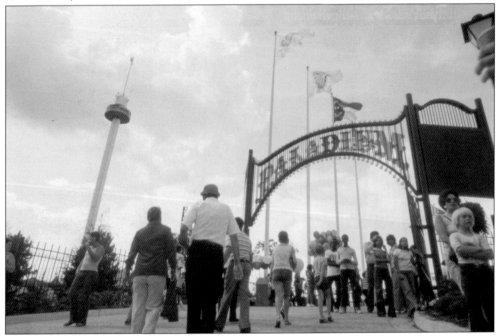

The main entrance to the new Paladium is pictured here with the Skytower rising in the background.

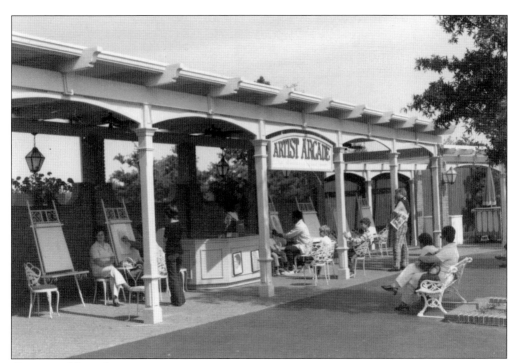

Guests could get their portraits painted or caricatures drawn at the Artist Arcade, a tradition that has lasted through the decades. Today, visitors can still sit for a portrait or caricature at kiosks around the park.

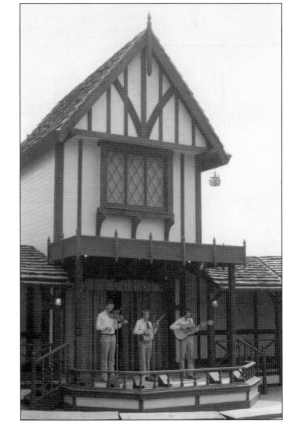

Troubadour's Roost, which was located in the Frontier Outpost section of the park, was home to a number of entertainers in Carowinds' early years. In this 1975 image, a trio playing violin, banjo, and acoustic guitar performs for guests on a warm summer day.

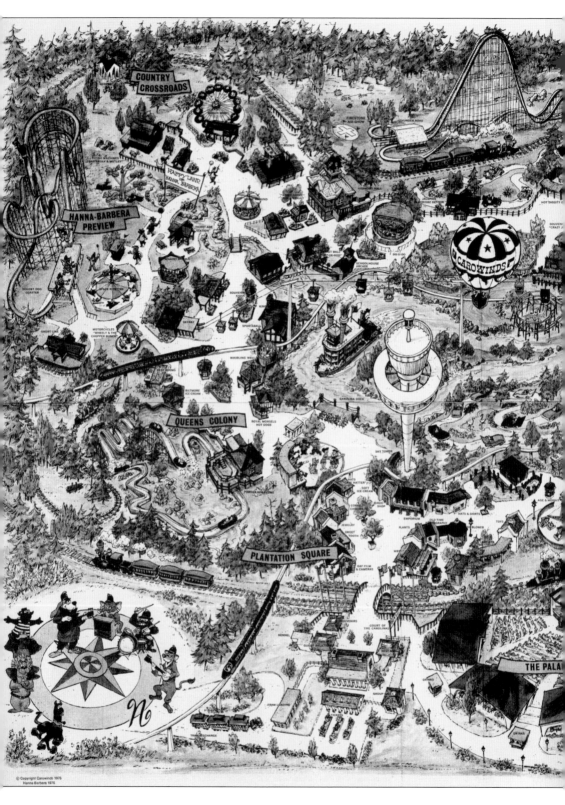

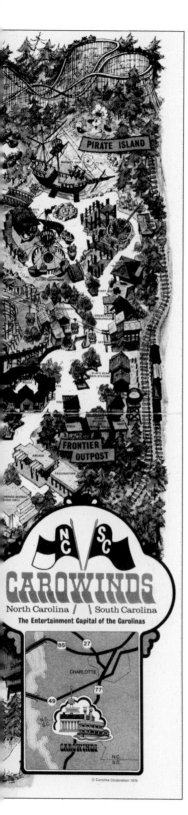

The official map from Carowinds' 1976 season illustrates the influence and dedication of its new owners. This is especially evident in the addition of attractions like the Scooby-Doo wooden roller coaster and six other flat rides added to the new Happy Land of Hanna-Barbera. For the 1976 season, the most impressive attraction was Thunder Road, a wooden racing coaster that was erected on the southwestern edge of Country Crossroads. However, the adjustment to the Carowinds & Carolina Railroad is conspicuous. Careful examination of the map reveals that two of the three passenger depots were closed. Both the Country Crossroads station and the lovely below-grade Plantation Square station were removed, leaving the Black Bear station as the sole boarding point. This decision proved to be prophetic, as the popular railroad was removed the following season.

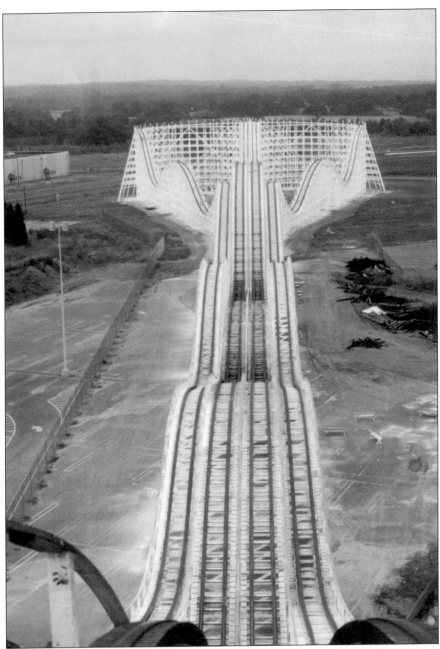

The 1976 season saw the addition of Thunder Road, the park's largest and most expensive ride to date. Thunder Road was based on a 1958 film of the same name that starred Robert Mitchum and focused on moonshiners evading the law in the mountains. In the spirit of the film, Carowinds outfitted the coaster's trains with faux automobile fronts (pictured on this book's cover)—one represented the hot-rodding moonshiners, while the other stood in for the sheriff's car. Thunder Road's layout was a virtual duplicate of the Rebel Yell at Kings Dominion, a wooden racing coaster that opened at the Virginia theme park in 1975. The coaster stood 93 feet tall and featured mirror-image out-and-back layouts measuring 3,819 feet each. The racing aspect of the ride induced a natural spirit of competition between riders.

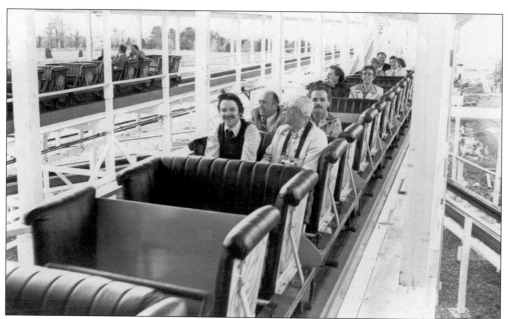

Unbeknownst to most guests, Thunder Road's beautiful articulated trains (above) originated at Chicago's famed Riverview Park. These spacious and comfortably upholstered cars were built in-house by Riverview Park staff to operate on the park's final wooden roller coaster (the Jetstream), which ran from 1965 until the park closed in 1967. Carowinds acquired these two trains and operated them on Thunder Road until 1980, when they were replaced with a quartet of lighter trains (below) purchased from Philadelphia Toboggan Company (PTC). Attentive observers will recognize Thunder Road's station as having an abundance of unused space on the up-track ends. This is because the original Riverview trains were significantly longer than the PTC models that replaced them.

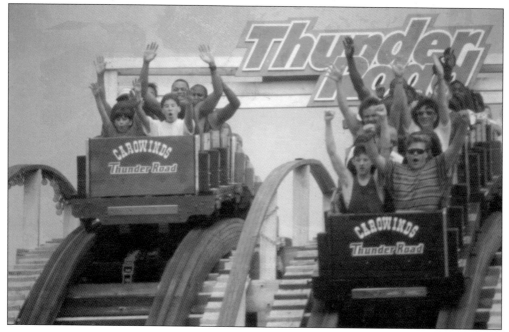

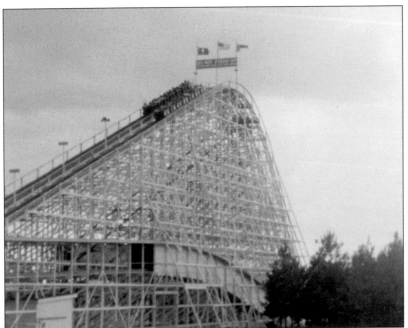

The skies darken during an approaching summer storm as Thunder Road's original trains near the top of the coaster's 93-foot-tall lift hill. Next up for these riders will be a rollicking race across the state line and back again.

A major marketing and publicity campaign accompanied the arrival of Thunder Road. The park featured a promotion in which guests could win the opportunity to be the first riders alongside NASCAR stars Bobby Allison (first row, kneeling second from left) and David Pearson (third row, first from left, looking away from the camera). Here, the winners and the popular race car drivers gather for a photograph in front of Thunder Road.

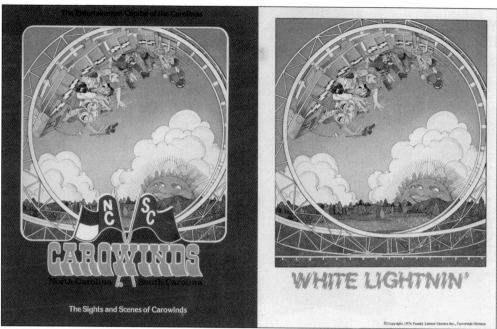

The Sights and Scenes of Carowinds

Carowinds was on a roll—literally. Thanks to a jump in attendance as a result of Thunder Road's installation the previous year, the park turned guests on their heads in 1977 with the installation of White Lightnin', a shuttle loop coaster designed by Germans Anton Schwarzkopf and Werner Stengel. The ride was often a challenge for the park's maintenance department but nevertheless became a favorite of the thrill-seeking crowd. This artwork from a Carowinds brochure captures the fun of White Lightnin'.

The White Lightnin' experience began with 28 passengers being loaded into a seven-car train. Once everyone was secured with a simple ratcheting lap bar, they were told to put their heads back against the headrest and hang on. Acceleration propelled the train down the launch track from zero to 60 miles per hour in barely three seconds. After rocketing through a vertical loop, the train scaled a near-vertical spike of track. Reaching a height of 130 feet, the train lost momentum, hung weightless for a moment, and then began to fall backward, only to repeat the entire adventure in reverse.

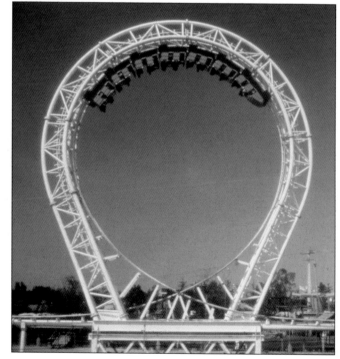

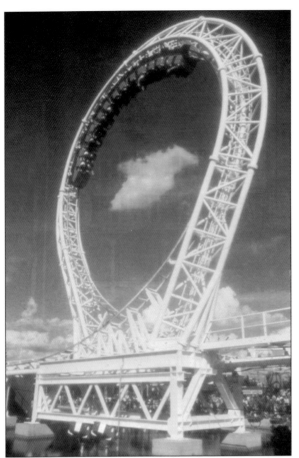

Much of the White Lightnin' structure and its signature vertical loop were located over water, which enhanced the thrill for riders and made for great reflective photographs.

White Lightnin' utilized a unique means of propulsion: a two-ton counterweight was housed in a hollow tower beneath the tall vertical spike at the far end of the course. This was attached to a cable system that connected to a "pusher" that made contact with the train in the station. When the counterweight was released, it literally dragged the train forward. This ingenious contraption remained a guest favorite until its last trip in October 1988. Today, White Lightnin' operates as the Golden Loop at the Gold Reef City amusement park in South Africa.

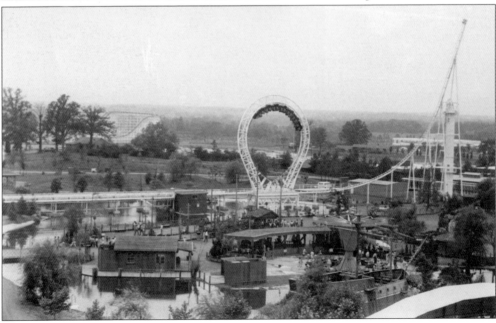

In 1979, the park embarked on another ambitious expansion and renovation program to add a new themed section, County Fair. With Thunder Road as the centerpiece, the section included four new rides, plus food, games, and entertainment centered around the theme of a local fair.

With Thunder Road's dual lift hill in the background, County Fair was also home to the Whirling Dervish (the Zierer Wave Swinger, right) and the Meteorite (the Schwarzkopf Enterprise, center).

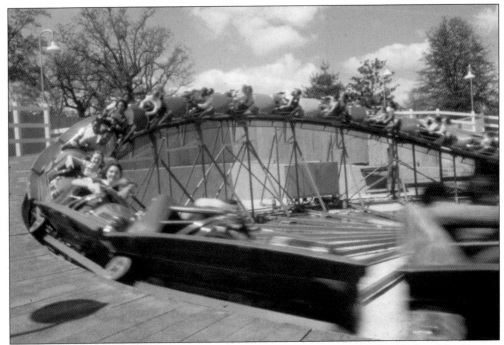

The Wild Bull, a Schwarzkopf-manufactured Bayern Kurve, was another highlight of the County Fair experience. This popular ride was imported from Germany and featured a train of low-slung bobsled-style vehicles that traveled around a banked track at high speed. After operating through the 1998 season, it was placed in storage and eventually sold for scrap.

No County Fair visit would be complete without a stop at the Demolition Derby, a classic bumper car attraction manufactured by Majestic Rides. The ride still exists today in County Fair as the Dodg'ems.

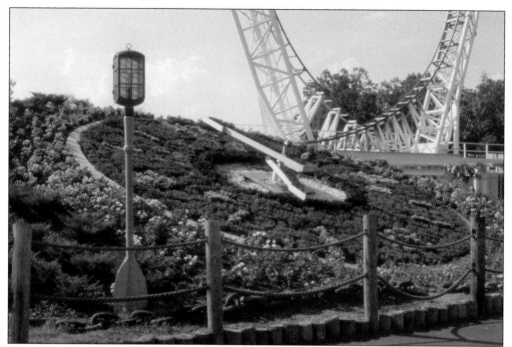

From the start, Carowinds has prided itself on keeping the grounds meticulously landscaped. For several seasons, this floral clock kept time while White Lightnin's vertical loop loomed in the background.

Keeping the park looking neat and trim busied a dedicated staff of groundskeepers throughout the year. While seasonal flowers and other foliage are a mainstay, a large number of trees planted during the park's early years have matured and now provide plenty of shade and natural beauty.

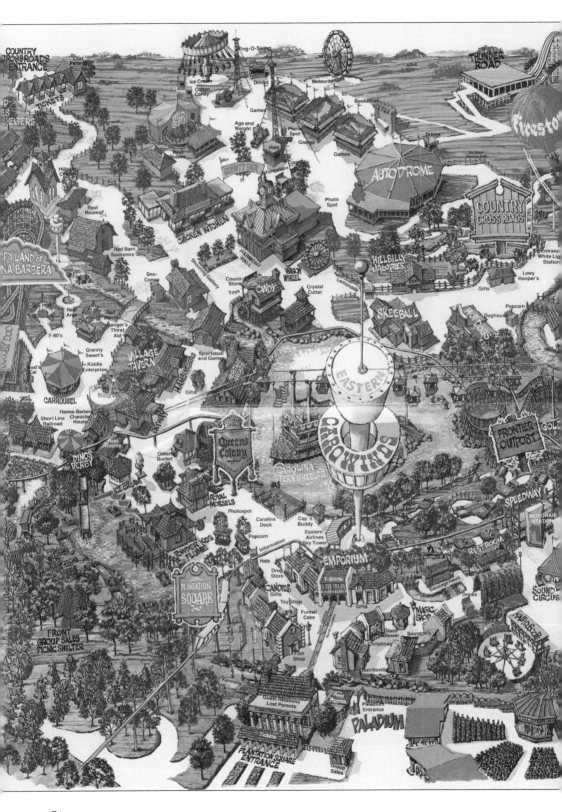

74

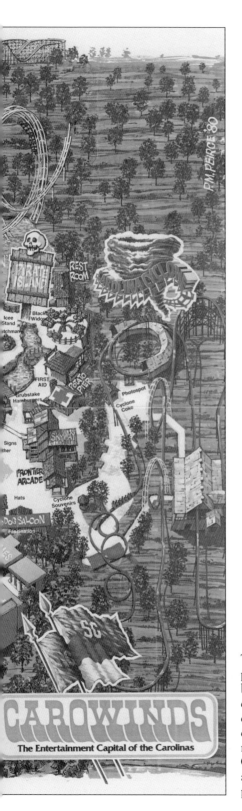

The dawning of a new decade is represented in this park map issued for the 1980 season. While the biggest improvement for guests was the opening of the quadruple-looping Carolina Cyclone roller coaster (far right), there were also some major changes taking place behind the scenes. Most notably, in October 1980, the Family Leisure Centers partnership between Taft Broadcasting and the Kroger Company was dissolved and the park became a fully owned subsidiary of Taft.

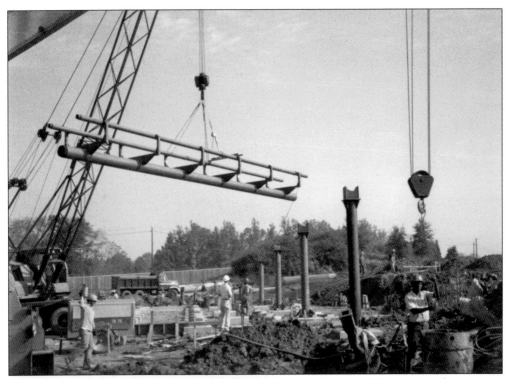

In the early 1980s, Carowinds was rapidly establishing itself as a thrill-ride destination—the one-two punch of Thunder Road and White Lightnin' had seen to that. In 1980, the park introduced yet another high-profile coaster—the Carolina Cyclone. The new ride had the distinction of being the first roller coaster on the planet to turn riders upside down four times. In this late 1979 image, workers prepare to place the section of track that will pass through the coaster's station.

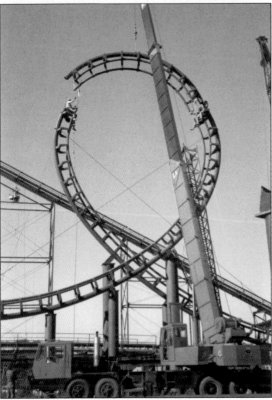

Construction moved along a rapid pace, as shown in this image of workers completing the Carolina Cyclone's second vertical loop. The completed ride stands 95 feet tall and features 2,100 feet of tubular steel track.

After climbing the lift hill, Carolina Cyclone riders are treated to this steep first drop that leads into two back-to-back vertical loops that are negotiated at 41 miles per hour.

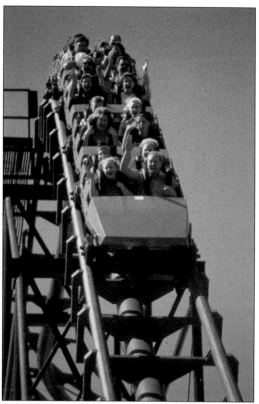

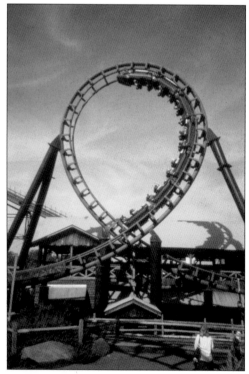

The Carolina Cyclone was designed and supplied by Arrow Development, the same company that built Carowinds' first roller coaster, the Goldrusher, five years earlier.

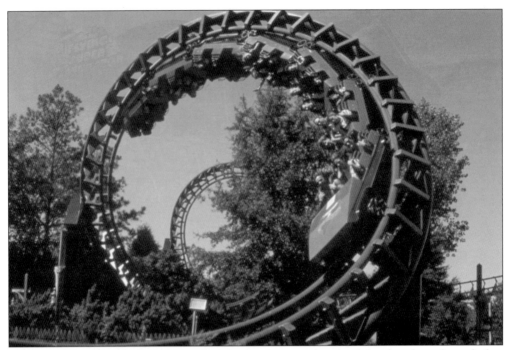

Following the vertical loops, the Carolina Cyclone's trains then bank hard to the right and whip through this double barrel roll (also known as a corkscrew) maneuver. A tunneled helix serves as a finale, after which the trains smoothly climb onto the brake run and then into the station.

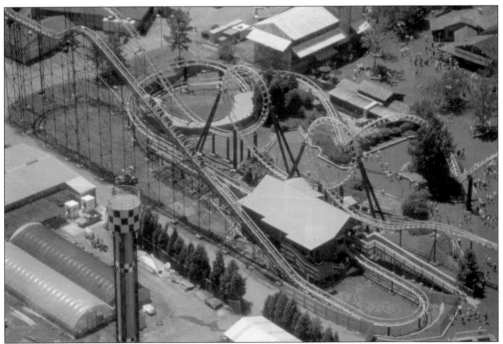

This aerial view of the Carolina Cyclone shows the coaster's complete layout. This record-setting attraction still thrills guests today just as it did on opening day in 1980.

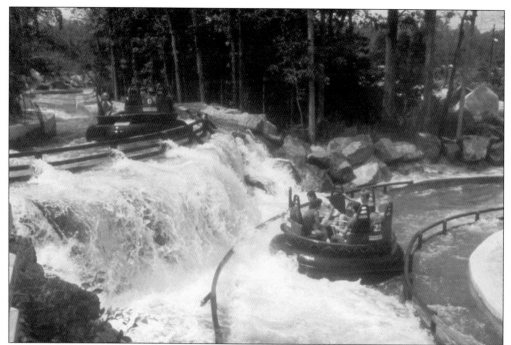

The 1982 season saw the introduction of Rip Roarin' Rapids, a multimillion-dollar white-water rafting attraction that was constructed within a wooded area near the Paladium. Here, two of the ride's eight-seat, free-floating round boats are shown on two different levels of the course.

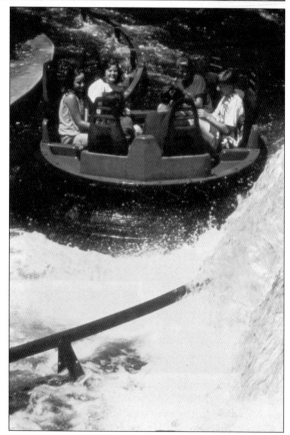

Rip Roarin' Rapids takes guests on a wet and wild trip down a 2,100-foot-long man-made river. It remains the perfect way to cool off on a hot Carolina summer day. As this photograph illustrates, staying dry is rarely an option.

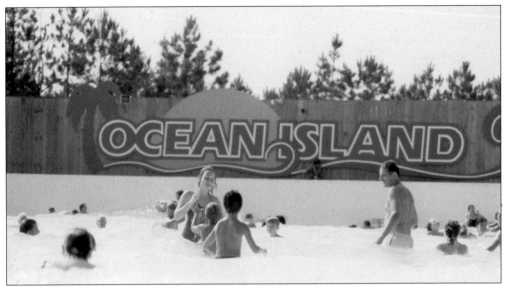

The Ocean Island wave pool—a 700,000-gallon, 25,000-square-foot swimming area featuring wave-generating technology—was also added in 1982. Ocean Island was situated on a 10-acre plot of real estate between Thunder Road and White Lightnin' but operated independently of the theme park. Visitors could choose to spend the day at Ocean Island without entering the park, while Carowinds guests could gain admission to the wave pool for a small surcharge.

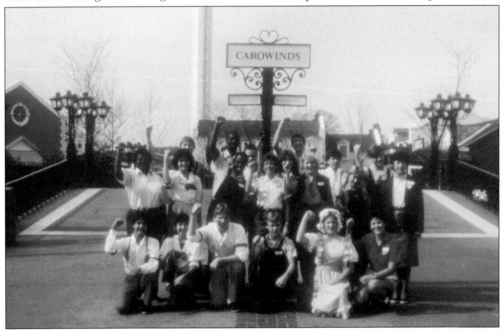

In 1983, Carowinds employees, sporting their various section uniforms, gathered for a lighthearted photograph at the state line. This was the final season that the park was under the ownership of Taft Broadcasting. In 1984, various executives from Taft's Amusement Park Group, including the park general managers and several vice presidents, came together to purchase two-thirds of Taft's interest in the park and formed their own company. The next season, Carowinds began operating under the Kings Entertainment Company (KECO).

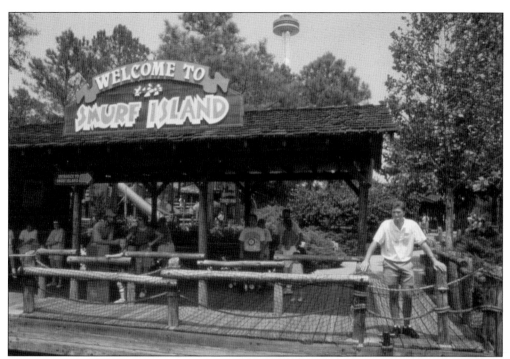

KECO hoped that Carowinds could capitalize on the success of another cartoon franchise with the opening of Smurf Island, which was located on an actual island surrounded by the river that was home to the Carolina Sternwheeler. Motorized barges (Smurf Boats) ferried guests across the water to Smurf Island. Here, guests congregate on the Smurf Island loading dock, which was located near Harmony Hall.

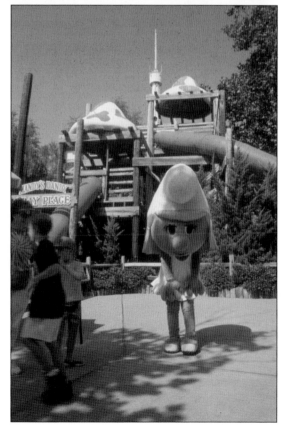

Guests could also access Smurf Island via a ramp on the left side of the Carolina Sternwheeler. On the 1.3-acre island, guests could interact with characters such as Smurfette and enjoy a play structure (pictured in the background) that featured climbing ropes, cargo nets, and 60-foot tubular slide.

An absolute favorite of Smurf Island visitors was the blue ice cream that was only available on the island. Guests who recall the sweet frozen treat still ask for it today.

This aerial view of Smurf Island offers a view of the four mushroom-shaped Smurf cottages. Young visitors could pretend they were part of the Smurf population and were actually able to play inside the structures.

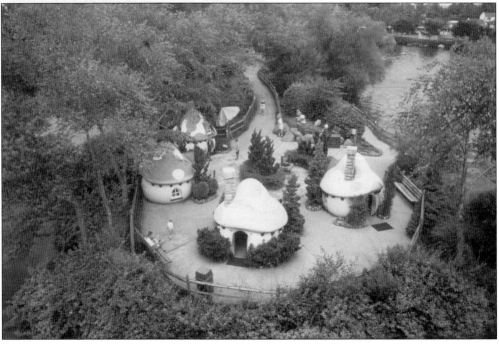

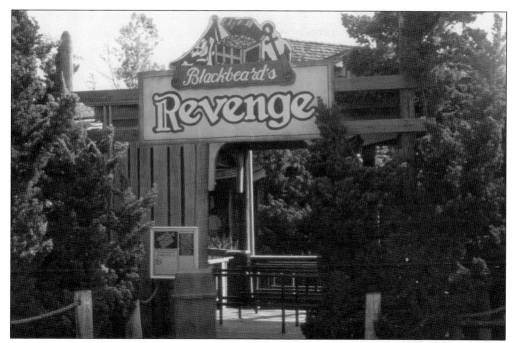

Carowinds' 1985 season kicked off with the addition of Blackbeard's Revenge, a new and unique attraction that combined the experience of a ride and a show. Named after the Carolinas' most infamous pirate, Blackbeard's Revenge utilized a huge pivoted room that rotated to create an illusory swinging effect for guests who were securely seated on a stationary platform.

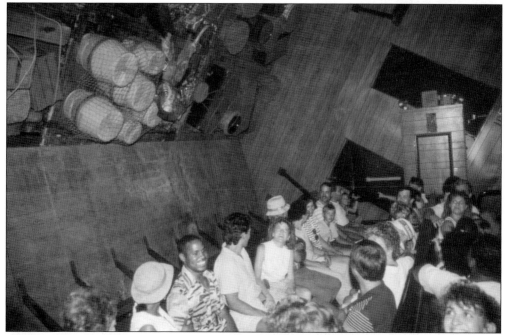

This interior photograph of Blackbeard's Revenge illustrates how at one point during the experience, the room would roll over, giving guests the feeling that they were upside down. Set decor and sound and lighting effects helped to bolster the illusion of being aboard a pirate ship during battle.

Frenzoid, a giant looping Viking ship designed and created by Intamin, was added to Carowinds in 1986. Frenzoid swung riders back and forth until finally suspending them completely upside down 80 feet above the midway.

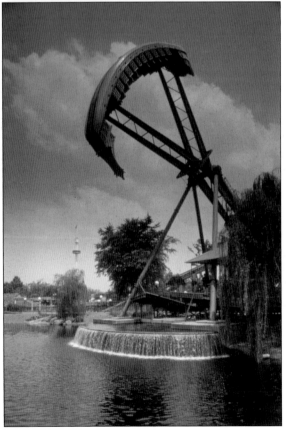

Frenzoid resided in County Fair, which underwent a major renovation in 1986 that included a 17,000-square-foot lake complete with a 45-foot-long, seven-foot-high horseshoe waterfall.

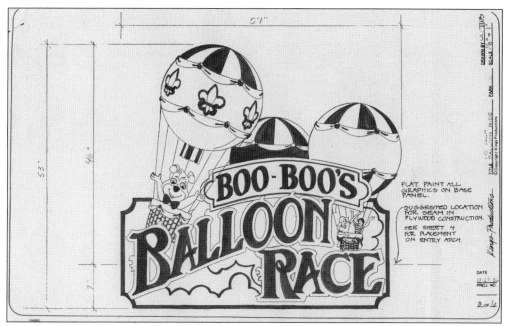

In 1986, the Carowinds Art Department created this original rendering of the entrance sign for Boo-Boo's Balloon Race in the Happy Land of Hanna-Barbera.

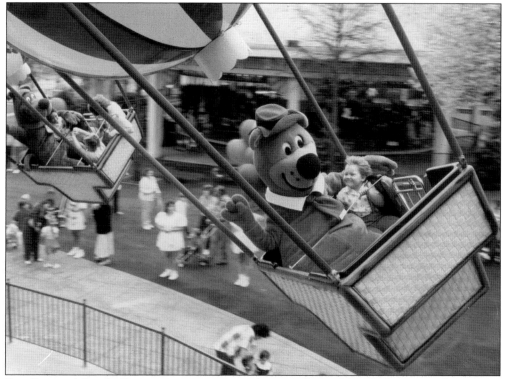

Yogi Bear and Scooby-Doo accompany young riders on a flight aboard Boo-Boo's Balloon Race. Prolific Italian ride manufacturer Zamperla created the ride. This popular attraction still operates today as Snoopy's Flying Ace Balloon Race.

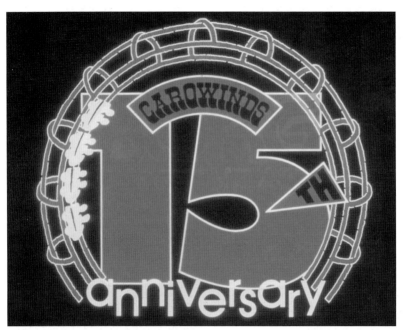

The Carowinds Art Department created this logo to commemorate the park's 15th anniversary in 1987. To mark the occasion, Carowinds added new rides to Hanna-Barbera Land (Boo-Boo's Balloon Race, Bamm-Bamm's Boat Float, and Elroy's Skychase) along with a 486-square-foot infant care facility.

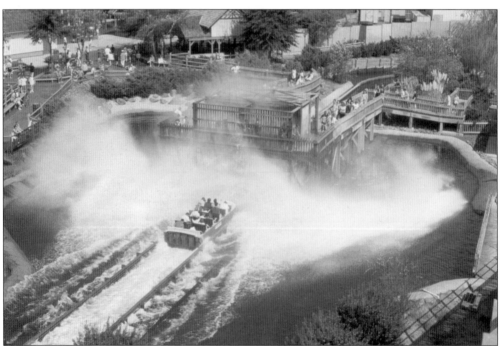

With the introduction of White Water Falls in 1988, Carowinds hoped to duplicate the success of its two previous water attractions, Powder Keg log flume and Rip Roarin' Rapids. Guests boarded 20-passenger boats that were taken to top of 50-foot lift, where they free-floated around a gentle 180-degree turn at treetop level. After plunging down a 45-foot drop, the adventure culminated in a spectacular splashdown at the bottom.

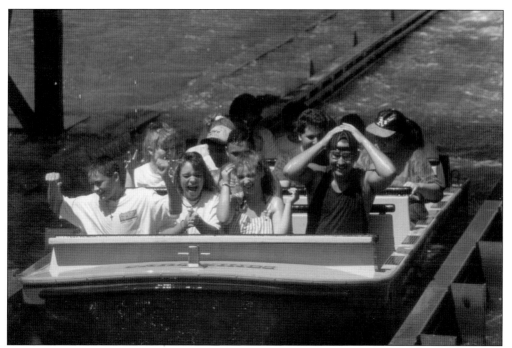

Water ride specialists Hopkins Rides created White Water Falls. One of the ride's boats is pictured here just after the giant wave has subsided. Water rides are always a good way to cool off on a hot Carolina summer day.

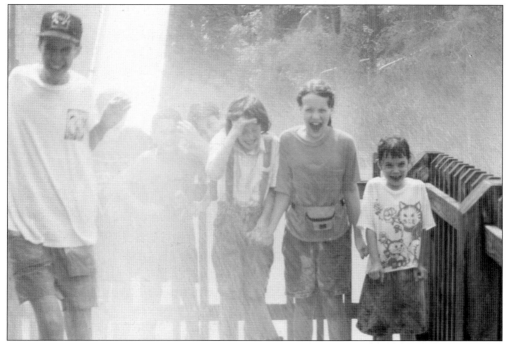

Spectators gather on an observation deck directly over White Water Falls' splashdown area. To this group's obvious delight, the resulting wave completely drenches them.

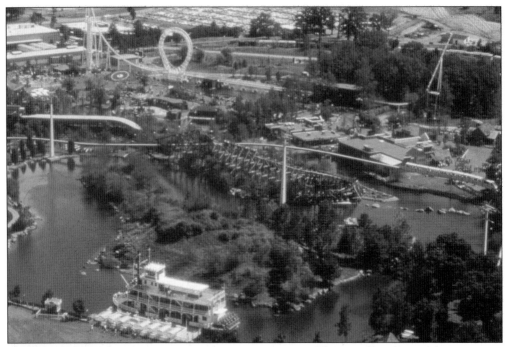

This aerial view was taken around the end of the summer in 1988. Unfortunately, this was the last year for White Lightnin' at Carowinds. When the park opened in 1989, the area where the much-loved roller coaster once sat was home to a new water park expansion called Riptide Reef.

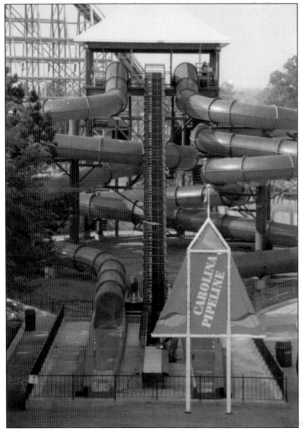

The Carolina Pipeline was just one of the many attractions at Riptide Reef in 1989. Carowinds became the first park in the country to offer a full water park along with a major theme park at no extra cost. The six-acre Riptide Reef was also home to Racing Rivers speed slides, Big Bay Wave (the renamed Ocean Island), and a children's play area.

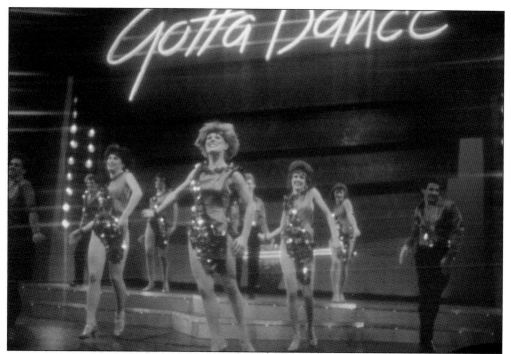

Carowinds' in-park entertainment continued with new productions like "Gotta Dance," a 1980s-themed presentation that reflected that raucous decade.

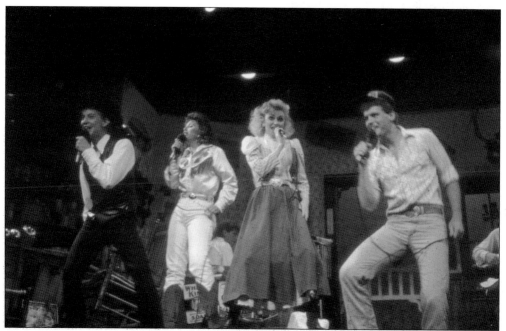

"Cross Country" illustrated how such shows continued to be a big draw as well as a way for guests to cool down in air-conditioned comfort.

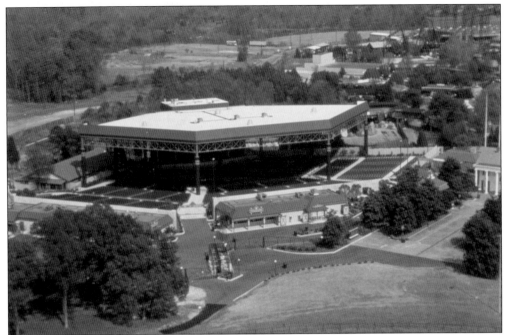

The Paladium was the subject of another major expansion in 1991, when construction raised the seating capacity to 13,000 and positioned the venue as a stand-alone concert facility separate from the theme park. The project also included adding a massive steel roof that covered the front 5,000 seats as well as replacing the existing bleacher seats with individual stadium-style seats with armrests and backs.

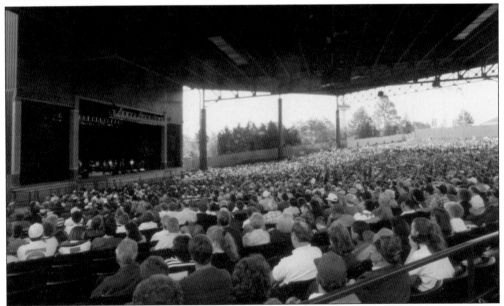

As illustrated in this wide-angle photograph of the crowd-filled Paladium, the renovations paid immediate dividends. The number of concerts presented in the venue in 1991 more than doubled compared to the previous season, and crowds came in record numbers to see acts such as Steve Winwood, Poison, Nelson, and David Lee Roth.

The 1992 season began with the addition of the Vortex, Carowinds' first new roller coaster since the opening of the Carolina Cyclone in 1980. Created by steel roller coaster experts Bolliger & Mabillard of Monthey, Switzerland, Vortex's claim to fame is the fact that guests ride in trains while standing up.

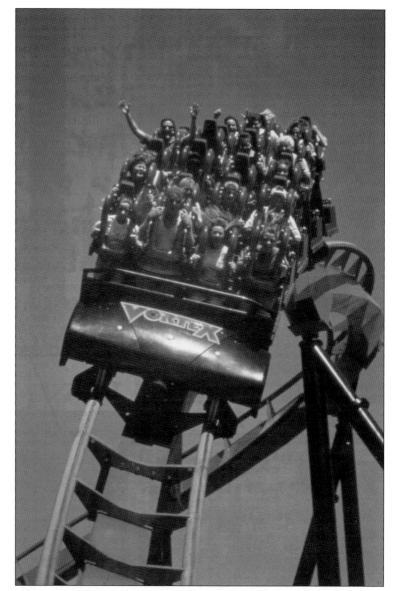

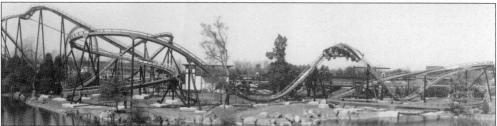

This panoramic view of Vortex shows its location beside the river that served the Carolina Sternwheeler. Vortex stands 90 feet tall and features 2,040 feet of steel track. The two trains reach a top speed of 50 miles per hour as they encounter a number of twists and turns as well as two inversions—a vertical loop and a corkscrew.

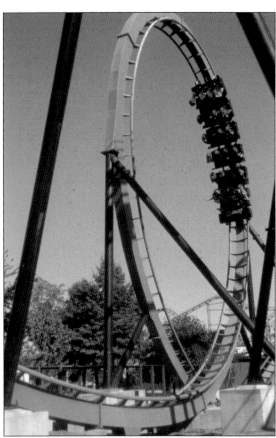

Here, Vortex riders are literally flipped head over heels as the train negotiates the ride's vertical loop, which occurs immediately after the twisted first drop of 90 feet.

One of the more disorienting maneuvers for riders aboard Vortex is the corkscrew near the coaster's conclusion.

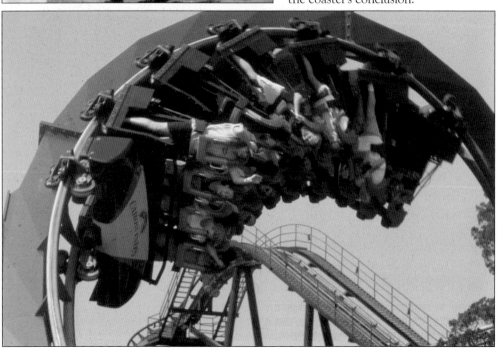

*Five*

# THE PARAMOUNT YEARS

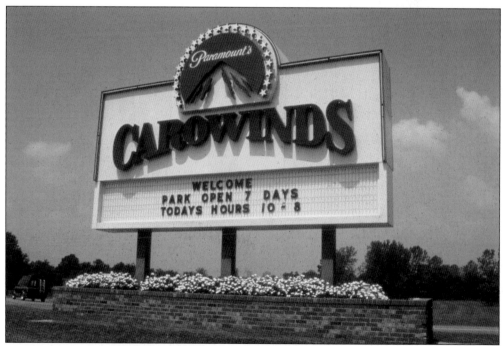

Midway through the 1992 summer season, on July 31, Paramount Communications, Inc., announced that it had purchased Kings Entertainment Company (KECO). Beginning in 1993, Paramount Parks would become the parent company of Carowinds, and the park would be renamed Paramount's Carowinds.

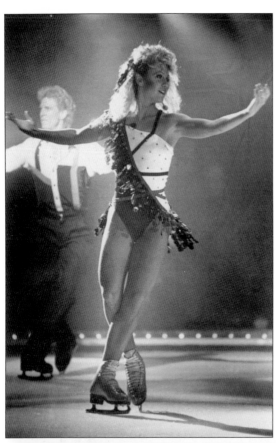

One of the first major projects of the 1993 season was the renovation of Midway Music Hall to accommodate a 40-by-40-foot ice rink stage. The venue was renamed Paramount Theatre and featured "Paramount on Ice," a professional ice-skating production.

Other new entertainment at Paramount's Carowinds included the appearance of Star Trek characters, including this away team that beamed into the "Paramount on Ice" show. Other Star Trek characters began to regularly show up in the park itself.

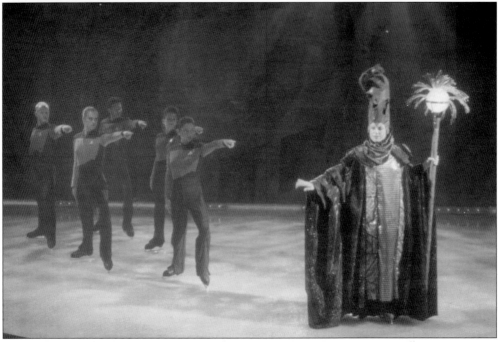

An additional improvement that reflected the influence of the new owners was the installation of "The Paramount Story," a series of granite blocks inlaid on the state line that detailed the star-filled highlights of noted Paramount movies and served as a chronological history of Paramount Pictures.

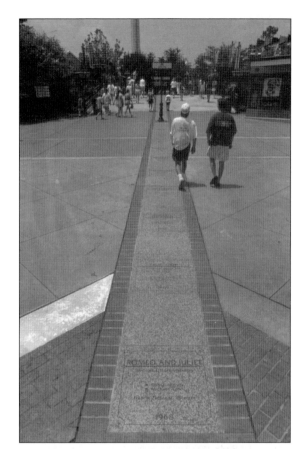

This crowd shot taken in Plantation Square in the early 1990s shows just how popular the park had become since its opening in 1972.

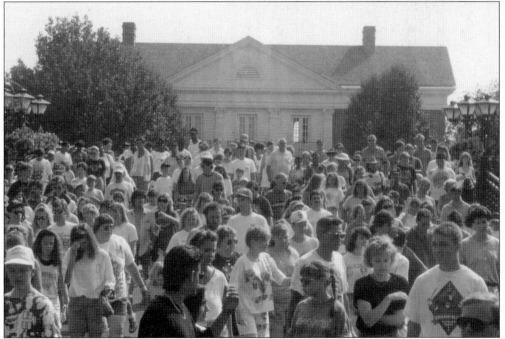

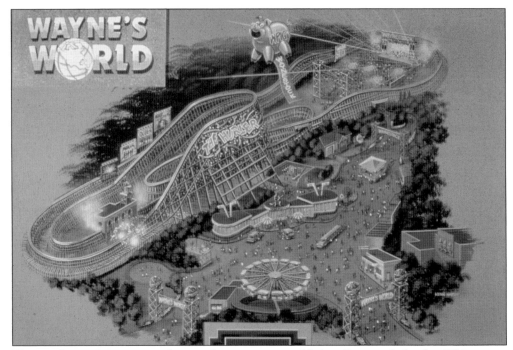

This rendering shows an aerial view of a new section added to Carowinds for the 1994 season. Wayne's World was based on a Paramount feature film and *Saturday Night Live* skit of the same name. The theming in the area was a recreation of the Aurora, Illinois, home of the main characters and included many props used in the film.

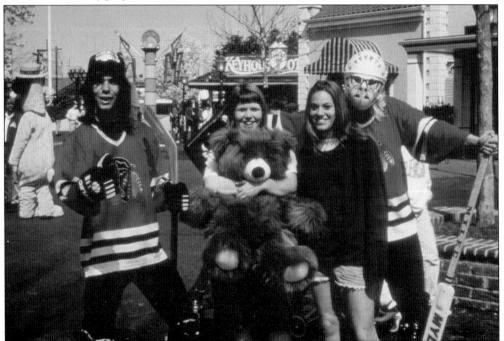

Wayne and Garth characters made regular appearances in the Wayne's World section of the park. Here, they pose with guests for a memorable souvenir shot.

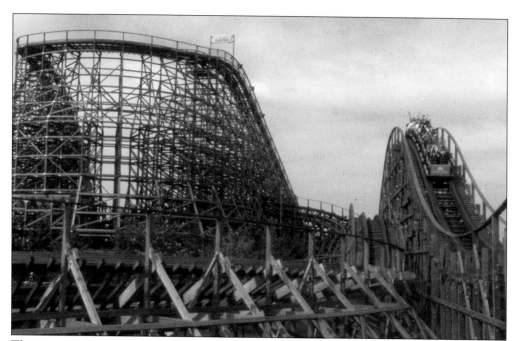

The signature attraction in the new Wayne's World area was North America's first movie-themed wooden roller coaster, the Hurler. Sporting a layout loosely based on a similar coaster at Kentucky Kingdom named Thunder Run, the Hurler featured an 83-foot lift hill and 3,157 feet of track. The ride experience was loaded with low speed hills and a number of ground-level banked turns.

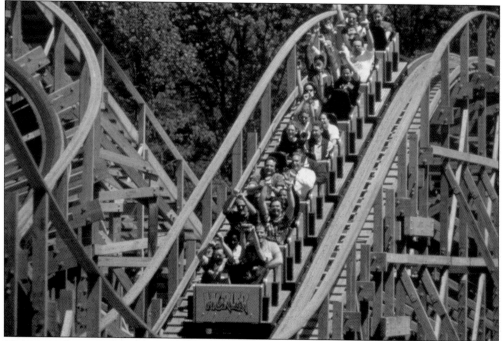

Here, one of two Hurler trains, which were created by Philadelphia Toboggan Company (the same manufacturer that built trains for the two other wooden coasters at Carowinds, Scooby-Doo and Thunder Road), is filled with guests enjoying the turbulent ride.

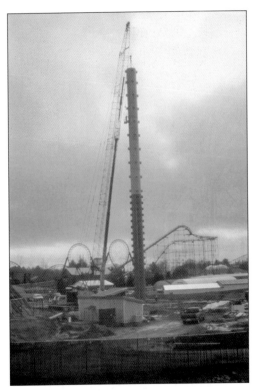

This image shows the construction of the Drop Zone Stunt Tower, a drop tower ride set to open in Wayne's World. Named after the 1994 Wesley Snipes film *Drop Zone*, the ride featured a quartet of four-seat carriages that were hoisted to the top of a 174-foot tower. After a brief pause, the carriages were released, and they would free fall for more than 100 feet before a magnetic braking system took hold and smoothly brought them to rest at the bottom.

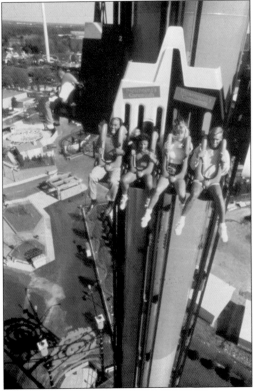

Drop Zone Stunt Tower riders are offered a spectacular view of Carowinds and the surrounding countryside, but it is a view they can only enjoy for a few seconds. They will have to hold on to their stomachs as they plummet toward the ground at 56 miles per hour.

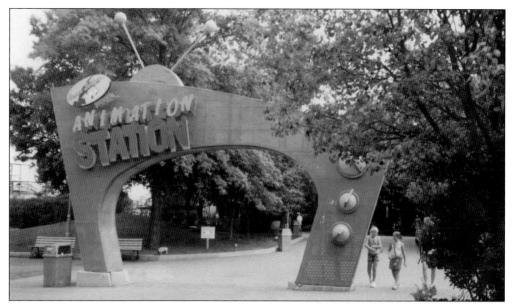

Carowinds' Hanna-Barbera section became Animation Station in the mid-1990s. Guests could enjoy existing attractions such as the newly renamed Scooby-Doo's Ghoster Coaster and the antique carousel, but they could also sample new attractions that completed the Animation Station experience.

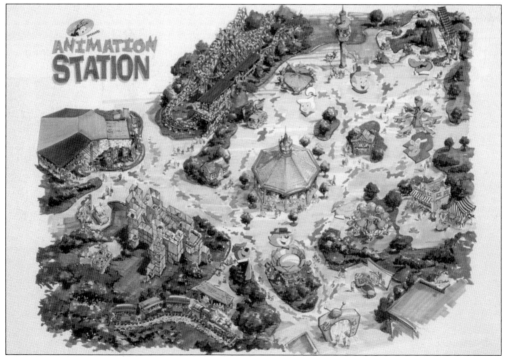

This aerial drawing of Animation Station shows added attractions such as the Power Station, a three-story climbing structure that featured 65,000 cubic feet of play area with ropes, slides, and towers. The largest addition to the area was Kid's Studio, an outdoor amphitheater that could accommodate 865 guests and featured two children's shows.

Carowinds beautiful antique Grand Carousel (PTC No. 67), located in Animation Station, is a favorite of carousel connoisseurs. Built in 1923 by the Philadelphia Toboggan Company, the Grand Carousel is the oldest ride in the park.

The Grand Carousel is a four-row machine that features 48 jumping horses, 20 standing horses, and two chariots. Before coming to Carowinds in 1973, it operated at two different parks in Evansville, Indiana—Pleasure Park (1923–1936) and Mesker Park (1936–1972).

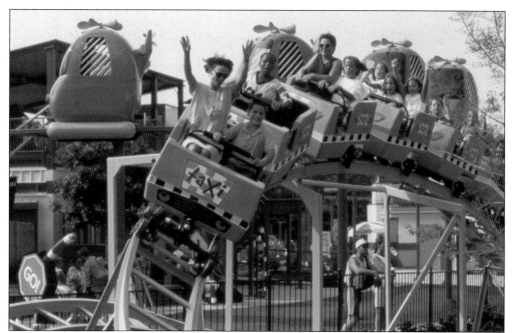

Taxi Jam was a small steel children's coaster that was created by E&F Miler Industries. The ride featured gentle hills and turns that were tailored to appeal to budding coaster fans.

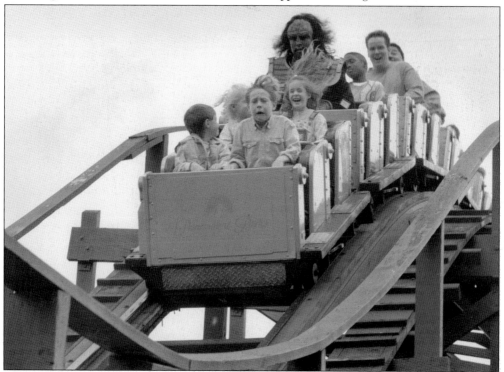

Who would have thought a Klingon from the Star Trek universe would enjoy a wooden roller coaster? In a clear display of the Paramount influence, this proud Klingon warrior shows his strength and endurance aboard Scooby-Doo's Ghoster Coaster during a publicity shoot.

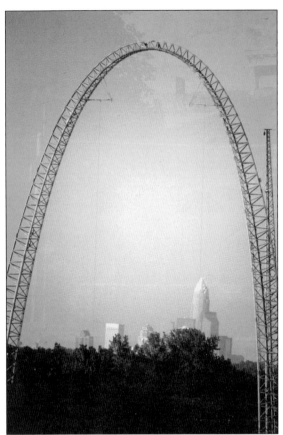

The mid-1990s also saw the arrival of an attraction unlike anything park visitors had ever seen. Xtreme Skyflyer (also known as Skycoaster) features a 172-foot-tall steel arch. The attraction combines the action of hang gliding, bungee jumping, and skydiving. The cityscape of uptown Charlotte, North Carolina, is visible in the background of this photograph.

To experience the Xtreme Skyflyer, guests have to be harnessed and attached to long cables that hang from the center of the arch. Here, a trio of fliers prepares for the adventure of a lifetime.

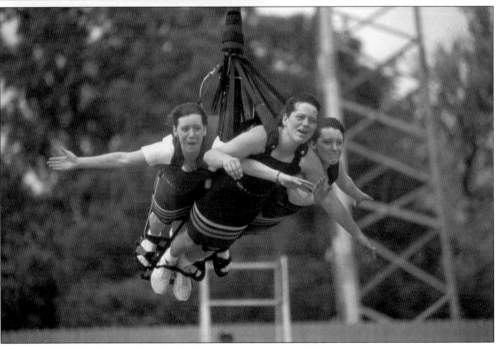

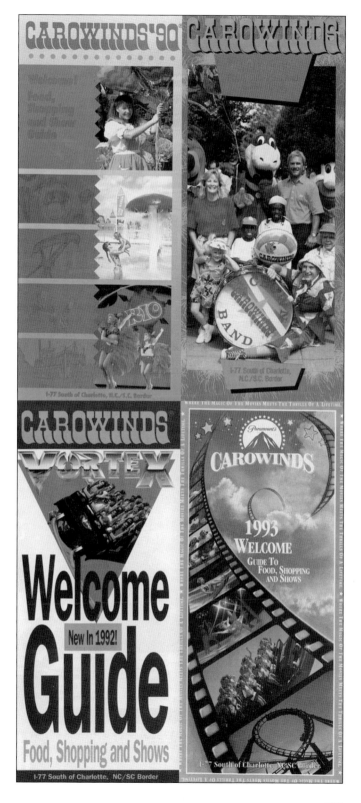

This selection of Carowinds brochures—including those from the years 1990 through 1993—offers a glimpse at the rides and attractions that came to the park in the early 1990s.

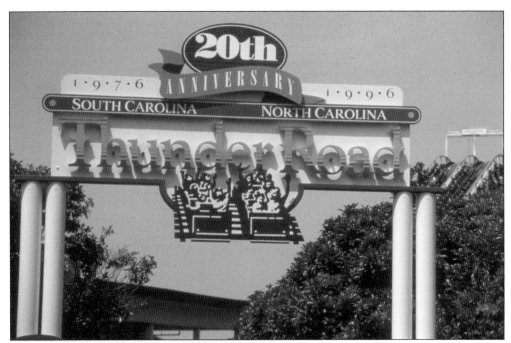

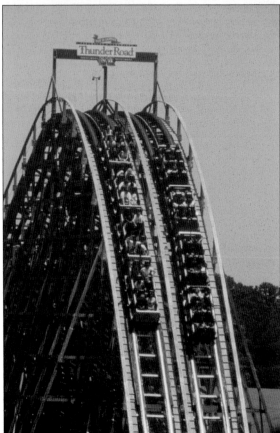

In 1996, this 20th anniversary sign was erected at the entrance to Thunder Road. For many longtime guests, it was difficult to believe that one of their favorite rides had been running for a full two decades.

A close look at this image will reveal that one train on Thunder Road is indeed backwards. From 1996 until 2008, the park ran one side of the racing coaster with the train facing backwards. For a while, it was an industry trend to reverse trains, especially when the ride in question had two separate tracks like Thunder Road, Kings Island's Racer, and Kings Dominion's Rebel Yell.

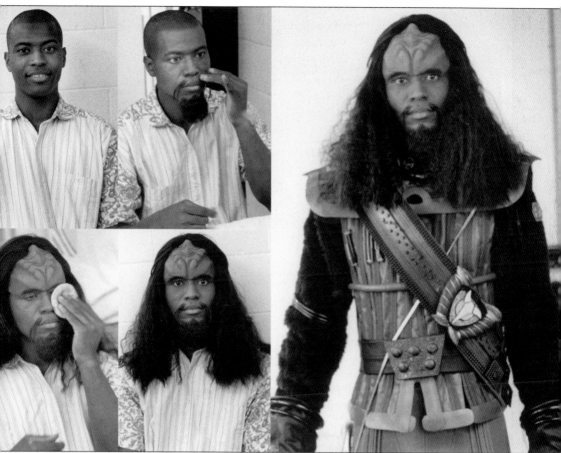

In this montage, Carowinds character actor Harold Jacobs chronicles the stages from human to Klingon as he becomes a Star Trek character. For most of the process, Jacobs would apply his own makeup.

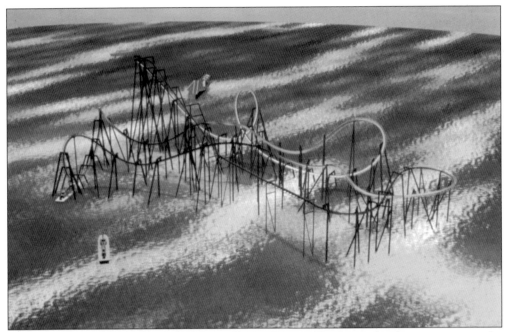

In 1999, Carowinds introduced Top Gun: The Jet Coaster, the largest single investment in the park's entire history. This aerial rendering illustrates the convoluted layout for the $10.5-million Bolliger & Mabillard inverted coaster.

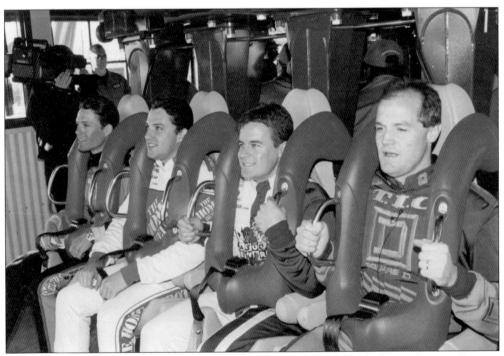

On hand for Top Gun's inaugural flight are, from left to right, NASCAR drivers Stanton Barrett, Tony Stewart, Jerry Nadeau, and Kenny Wallace. Note that they are all secured with Bolliger & Mabillard's over-the-shoulder restraint system.

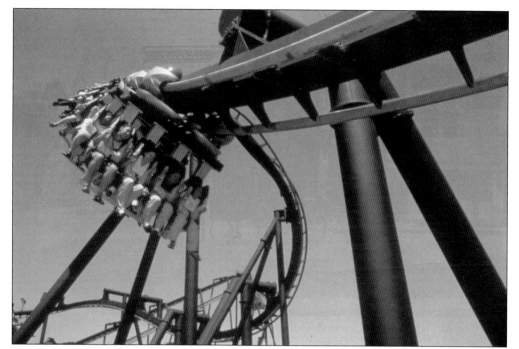

Top Gun stands 113 feet tall and features 2,956 feet of track that includes six complete inversions and a top speed of 62 miles per hour. In this view, one of two Top Gun trains is completing the final inversion, a corkscrew.

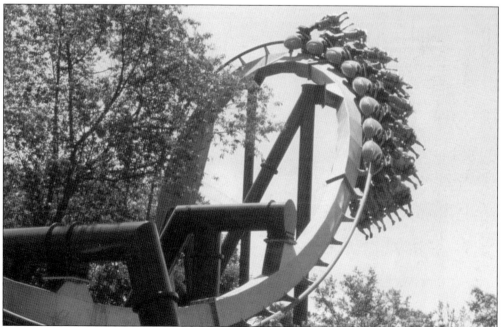

Top Gun (now renamed Afterburn) remains a favorite among coaster fans for its unique ride layout characteristics. Chief among those is the batwing, a double inverting element that finds the train speeding into a tunnel that burrows beneath the walk leading from the park's south entrance. Here, the train has just left the tunnel and completed the second half of the batwing.

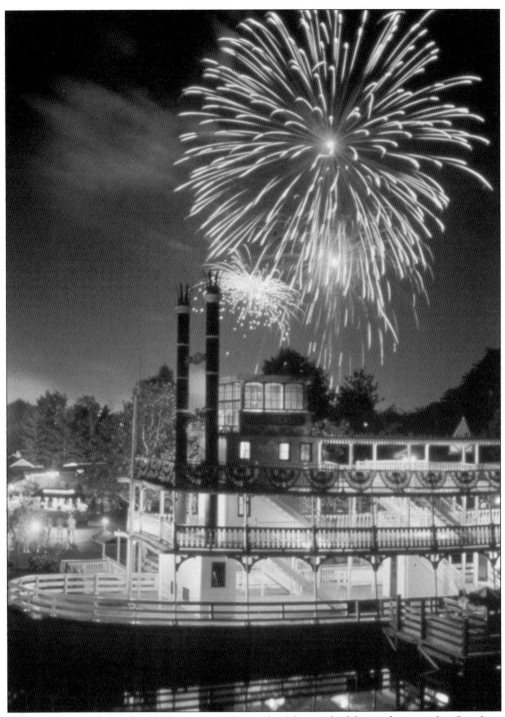

Carowinds completes the 1999 season with a colorful round of fireworks over the Carolina Sternwheeler. Though the 20th century came to a close, Paramount's ownership of the park continued into the bright new millennium with plenty of excitement and attractions in store.

*Six*

# THE NEW MILLENNIUM

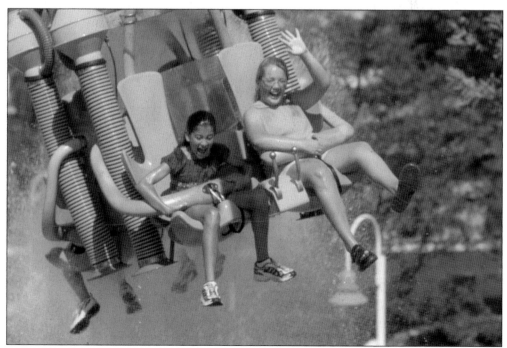

Still under the guidance of Paramount, Carowinds began the 2000s with the introduction of its 10th roller coaster, the Nickelodeon Flying Super Saturator. Designed and built by the Utah-based Setpoint, this interactive attraction took the adventure of the suspended coaster and combined it with a water play experience. The result was a high-flying, drenching experience like no other.

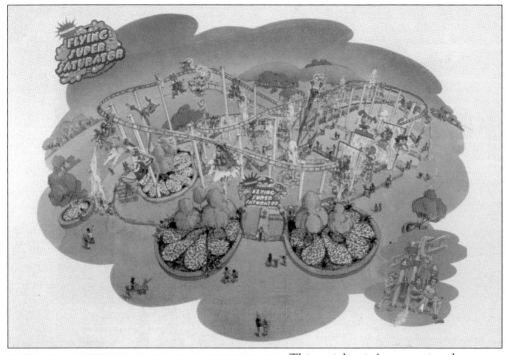

This aerial artist's conception shows the 1,087 feet of overhead track along which riders would glide all the while encountering water curtains, geysers, and other special effects. The ride was themed with signage and graphics reflecting Nickelodeon's most popular characters.

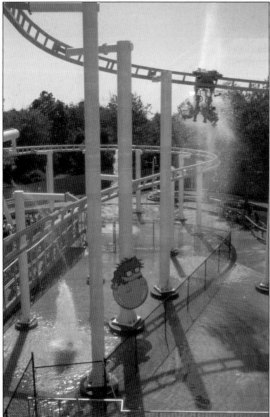

Each of the Flying Super Saturator's vehicles accommodated four riders seated in back-to-back pairs. The vehicles contained 16-gallon onboard reservoirs that were filled in the station during the boarding process. Once the vehicle was in the air, riders could use hand levers to release the water on guests waiting below in the queue. There were also 22 spray stations located around the attraction that allowed spectators on the ground to soak riders. The Flying Super Saturator, which closed in 2008, is one of only two roller coasters retired by Carowinds (the other being White Lightnin').

Watt Burris was one of Carowinds' most well-liked and respected officials. He began his amusement industry career with Carowinds in 1975. After heading north to sister park Kings Dominion, where he held the position of general manager from 1984 until 1992, he returned to his roots and worked at Carowinds from 1992 until he retired in 2002. He passed away in 2004. Pictured here with his signature broom and dustpan, he was instrumental in showing that even the highest-level employee is not above performing the most menial of tasks. This tradition among park managers continues today.

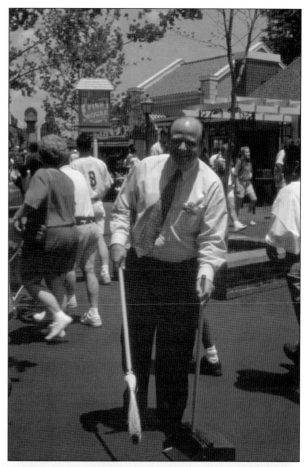

This original, one-of-a-kind oil painting depicting Thunder Road during its opening season hung in Burris's office for many years during his tenure at Carowinds. Upon retiring, he presented this treasure to the author of this book, who considers it among his most prized amusement industry possessions.

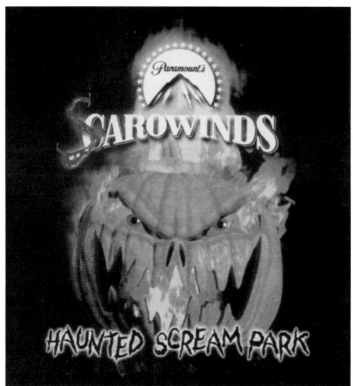

Scarowinds, the haunted theme park, was introduced in 2000 to great success. Pictured here is the event's first logo and promotional poster featuring an evil jack-o-lantern.

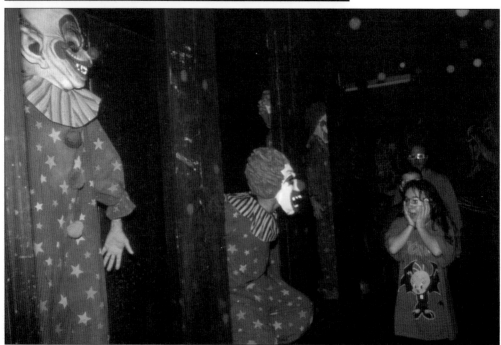

TerroVision was one of the more harrowing attractions at Scarowinds. Once inside, guests encountered a number of static displays as well as live actors who were instructed to scare visitors out of their wits. Here, evil clowns menace all who approach their lair.

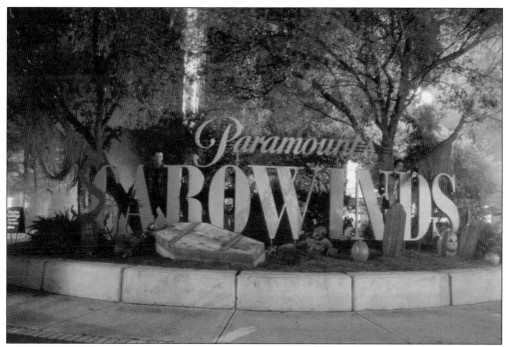

Here, the Scarowinds sign at the park entrance is draped in spooky cobwebs. Scarowinds sophomore year was overshadowed by the terrorist attacks of 9/11, which cast a shadow across the entire nation. In 2002, Scarowinds was significantly expanded to include the entire park.

Though not an official part of Scarowinds, Scooby-Doo's Haunted Mansion took up residence in Harmony Hall. The former entertainment venue was completely transformed into an old Southern plantation that housed the interactive dark ride supplied by the Sally Corporation. Guests used lasers to shoot at various targets situated along the dark, convoluted track layout. On-board digital displays showed the riders' scores. Today, the attraction is known as Boo Blasters on Boo Hill.

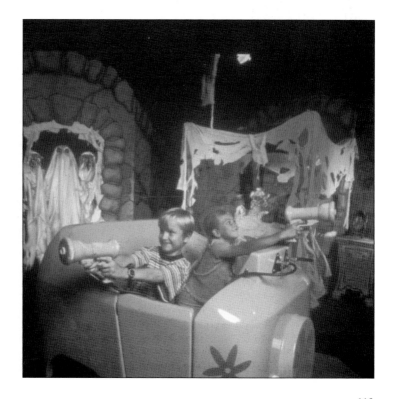

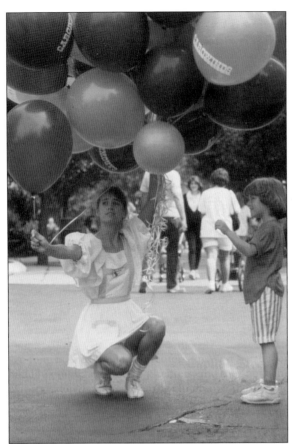

Carowinds' popular "balloon girl" program remained in effect until the early 2000s. Though no specific date was selected for its termination, the positions were slowly phased out due to staffing shortages. Here, a balloon girl pauses to offer a colorful balloon to a child.

Park officials participate in the ribbon-cutting ceremony for Ricochet, a steel roller coaster that opened in 2002. The ride anchored the new Carolina Boardwalk section, an area that paid tribute to the world-famous beaches of the Carolinas.

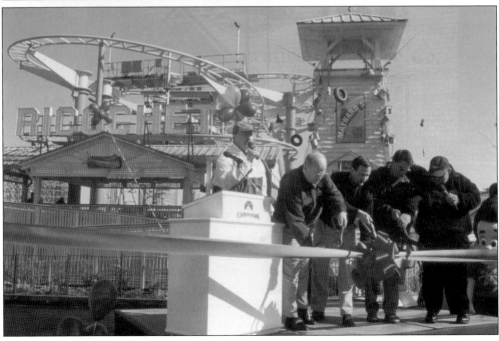

Ricochet, the park's 11th roller coaster, is a Wild Mouse–style steel model designed by Germany's Mack Rides. The design of this coaster was based on a wood-structured ride patented by Franz Mack that reached its height in popularity in 1950s Germany and eventually came overseas to North America. The coaster utilizes eight four-seat vehicles.

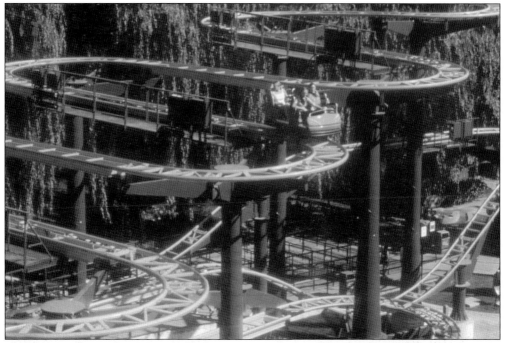

Standing at more than four stories tall, Ricochet features 1,219 feet of steel track containing hairpin turns punctuated with steep drops. Riders experience speeds up to 28 miles per hour as the tiny cars whip around the compact course.

Two young guests try out their driving skills aboard miniature electric cars on the Rugrats Toonpike. When the Peanuts characters arrived, the ride was renamed Joe Cool's Driving School; it was removed to make way for Dinosaurs Alive!, which opened at Carowinds in 2013.

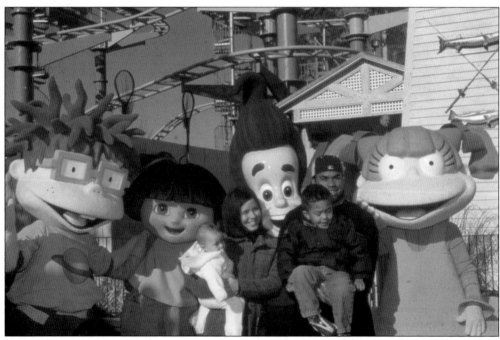

Nickelodeon's Dora the Explorer, Jimmy Neutron, and a pair of Rugrats pose for a photograph with a family of guests in front of Ricochet in Carowinds' Carolina Boardwalk section.

Adventurous guests enjoy a flight aboard the Rugrats Runaway Reptar, a Suspended Family Coaster that opened in 2003. Designed by Vekoma, a Netherlands-based company, this was a scaled-down version of Vekoma's popular Suspended Looping Coaster found at other parks around the world.

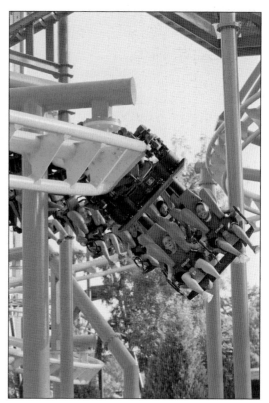

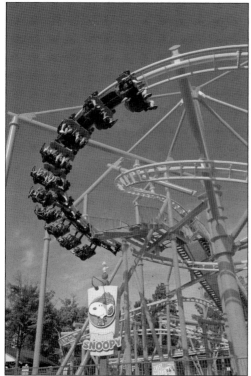

Here, a fully loaded 10-car train on the Flying Ace Aerial Chase (the renamed Rugrats Runaway Reptar) soars gracefully around a turn on the coaster's compact 1,122-foot-long course. When Paramount sold the park to Cedar Fair in 2006, this ride's name was changed to reflect the Peanuts theme.

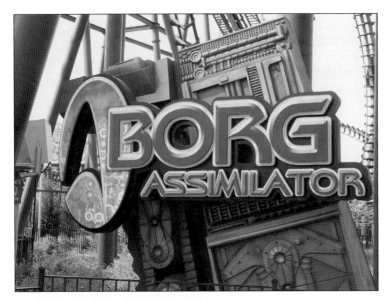

This is the entrance sign for the $17-million BORG Assimilator, which invaded Carowinds in 2004. Sporting a theme lifted from one of Star Trek's most notorious villains, BORG Assimilator was the first Flying Dutchman coaster created by Vekoma. Before being transported to Carowinds, the ride spent three seasons as Stealth at California's Great America.

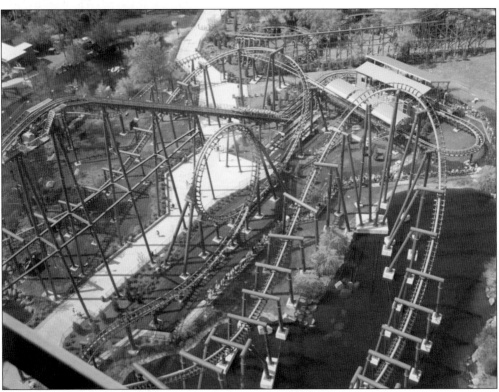

This aerial shot of BORG Assimilator, taken from the Skytower, shows much of the coaster's 2,766 feet of track. Guests board the ride's trains in the sitting position but are then lowered into a prone position facing the sky. After climbing the 115-foot-tall lift in this position, the six-car trains suddenly roll over at the top and allow guests to "fly" like Superman through the rest of the ride.

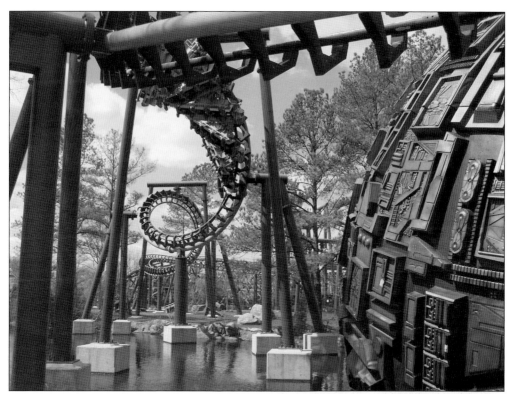

One of BORG Assimilator's trains prepares to enter the double corkscrew element, which will completely invert riders twice before heading back to the boarding platform. At right is a major facet of the coaster's incredible theming, a realistic Borg sphere (a formidable spaceship in the Star Trek world).

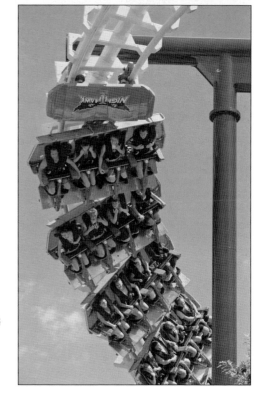

After Paramount sold the park in 2006, BORG Assimilator became known as Nighthawk. This photograph illustrates how riders, seated four abreast in the six-car trains, are secured with an elaborate restraint system.

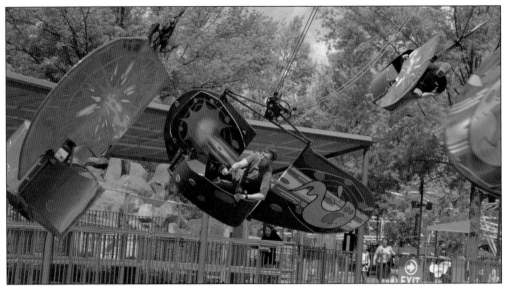

In this 2005 photograph, guests take flight on one of Carowinds' most entertaining and historical attractions, the Nickelodeon-themed Danny Phantom's Phantom Phlyer (since renamed the Woodstock Gliders). In industry parlance, this wonderful ride is known as a Flying Scooter. Bisch-Rocco Amusement Company produced numerous examples, including this one, between 1935 and 1960. This particular model carries an interesting pedigree: it first took to the skies at Ohio's Coney Island in 1936 and operated until that park closed in 1971. Along with many of Coney Island's rides, it migrated to the Paramount-owned Kings Island, operating there as the Flying Eagles until 2004.

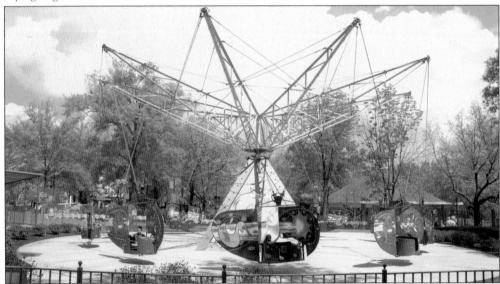

At first glance, one might consider the Flying Scooter to be a kiddie attraction. Though it can offer a gentle experience, those in the know can truly make it fly, dive, and whip through the air. This photograph shows Carowinds' 10-car Flying Scooter ride loaded and preparing to take flight. Once aloft, guests can use a hand-operated pivoting-forward rudder to alter the trajectory of their individual tubs. This ride, currently known as the Woodstock Gliders, has a loyal following with fans continually queuing up for the experience.

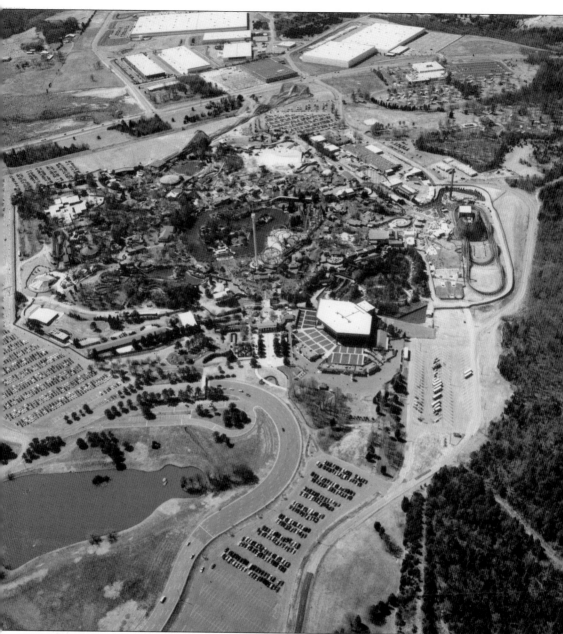

This aerial view shows just how much the landscape of Carowinds had changed by the mid-2000s. On July 1, 2006. Carowinds announced that the park had been purchased by Cedar Fair Entertainment Company, (NYSE: "FUN") a publicly traded partnership headquartered in Sandusky, Ohio. As of 2013, the company owned and operated 11 amusement parks, four outdoor water parks, one indoor water park, and five hotels across the United States and Canada, making it one of the largest regional amusement park operators in the world. Cedar Fair also operated the Gilroy Gardens Family Theme Park in California under a management contract. This 2006 acquisition tied Carowinds to Cedar Fair's flagship park, Cedar Point, consistently voted the "Best Amusement Park in the World" in a prestigious annual poll conducted by *Amusement Today* newspaper.

Carowinds' first seasons under Cedar Fair saw even further expansion of Boomerang Bay, the newly branded Australia-themed water park that opened in 2006. Along with many improvements, guests were treated to Bondi Beach, a new 600,000-gallon wave pool created by Neuman Pools of Wisconsin. The wave pool can generate waves of varying heights and patterns. Admission to the water park is included with admission to Carowinds.

Here, children find cool relief from the Carolina summer on the Sydney Sidewinder, one of Boomerang Bay's waterslides. Designed by water ride experts ProSlide Technology, Sydney Sidewinder features a pair of open tube slides that allow guests to splash through 370-foot-long dual courses loaded with high-banked twists and turns.

This image evokes pure summertime joy as a young guest relishes the splash of cool water at Boomerang Bay's Jackaroo Landing. This expansive water jungle gym attraction allows kids to control the water sprays, wheels, and other diversions. A highlight of this section is a huge, 1,000-gallon drenching bucket that periodically pours its contents onto those below.

This giant mushroom fountain is one of several that can be found at Kookaburra Bay, a children's section of Boomerang Bay that includes pools for infants and toddlers as well as separate changing areas, restrooms, and lockers.

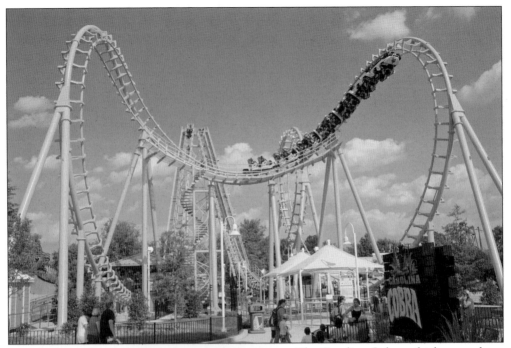

The Carolina Cobra, which opened at Carowinds in March 2009, is a compact shuttle loop coaster known as a Boomerang. Manufactured by Vekoma, the Cobra features 935 feet of track that riders experience both forwards and backwards. The twisted track section in the foreground is the ride's signature boomerang element. Before coming to Carowinds, this coaster was known as both Mind Eraser and Head Spin when it operated at Geauga Lake in Aurora, Ohio, from 1996 until that park closed forever in 2007.

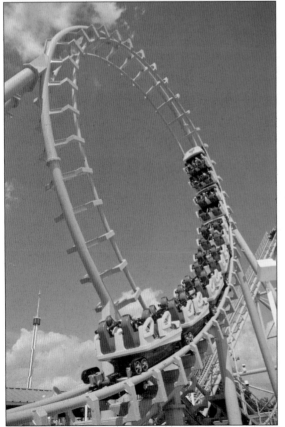

Just seconds before this image was captured, the Carolina Cobra's seven-car train had been hauled by chain to the ride's second 116-foot-tall track spike. It was then released to coast backwards and negotiate this vertical loop at 47 miles per hour.

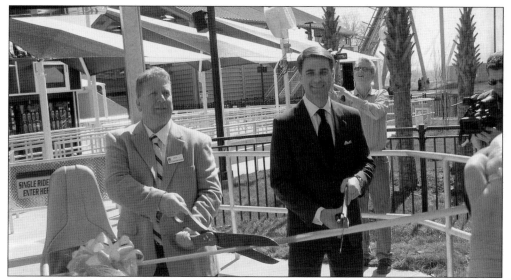

The skyline of Carowinds dramatically changed in 2010 when the park introduced Intimidator, the Southeast's tallest, fastest, and longest roller coaster. Topping the list as the largest single capital investment in Carowinds' 37-year history, the Intimidator was named in honor of NASCAR's most beloved driver, Dale Earnhardt. This picture shows Carowinds general manager Bart Kinzel (left) and South Carolina lieutenant governor Andre Bauer cutting the ribbon at Intimidator's grand opening on March 27, 2010.

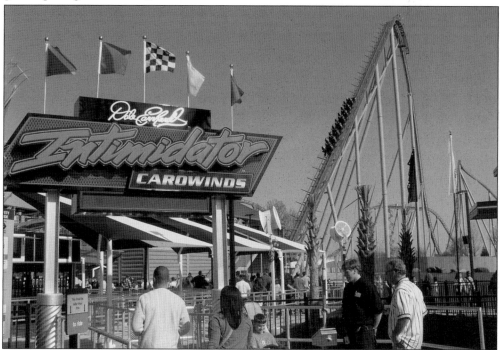

This photograph captures Intimidator's entrance along with a train at the midway point of its quick ascent to the top of the 232-foot-tall lift hill. Once over the crest, riders plunge down a 21-story drop angled at a steep 74 degrees. At the bottom, the coaster hits a blistering top speed of 75 miles per hour before racing back into the sky.

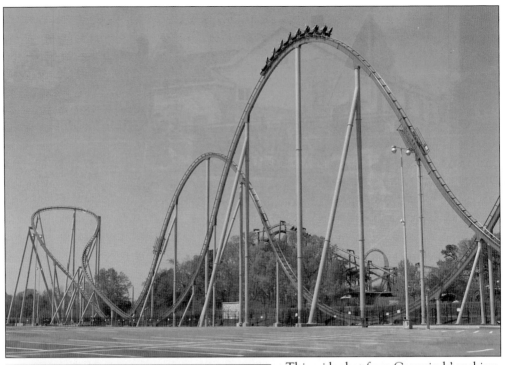

This wide shot from Carowinds' parking lot shows one of Intimidator's three eight-car trains whipping over the ride's third hill, which—at 151 feet—is far taller than most coasters' first hills.

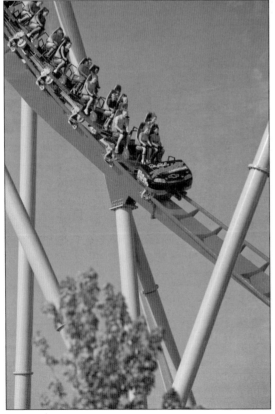

This photograph offers a glimpse of one of Intimidator's sleek, 32-seat trains as it roars down the coaster's 178-foot second hill. In a nod to the automobile fronts created for Thunder Road in 1976, Intimidator's pilot car sports a custom nosepiece tailored to resemble Dale Earnhardt's famous No. 3 car.

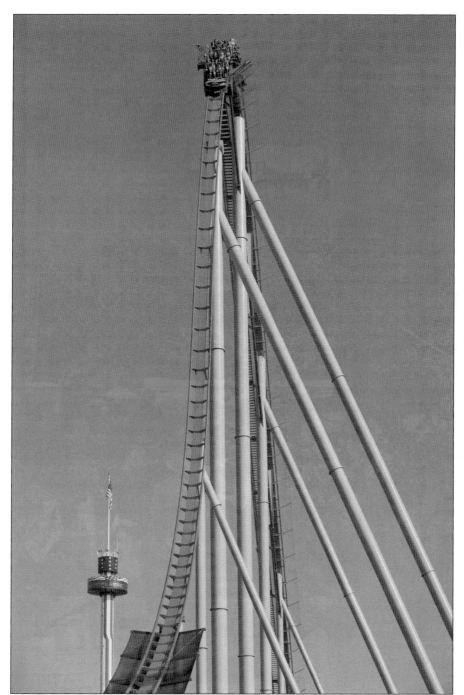

This amazing view of Intimidator's 232-foot-tall first hill shows the train poised on the edge and about to embark on an adventure like no other. For those on board, it might equate to the amazing journey Carowinds has been on since it opened in 1973. Surely, E. Pat Hall would be proud of what his park on the border of the Carolinas has become. Most likely, he would be seated right there in the front seat with a knowing smile, satisfied that his dream was in good hands with a future as bright as the Carolina sun.

# DISCOVER THOUSANDS OF LOCAL HISTORY BOOKS FEATURING MILLIONS OF VINTAGE IMAGES

Arcadia Publishing, the leading local history publisher in the United States, is committed to making history accessible and meaningful through publishing books that celebrate and preserve the heritage of America's people and places.

## Find more books like this at
## www.arcadiapublishing.com

Search for your hometown history, your old stomping grounds, and even your favorite sports team.